e-flux journal

Benjamin H. Bratton

Dispute Plan to Prevent Future
Luxury Constitution

Sternberg Press

Contents

Keller Easterling
5 **Foreword: Another Part of Speech**

10 **The Orchid Mantis of Sanzhi**

13 **The Role of Megastructure in the Eschatology of John Frum (On OMA's Master Plan for the Spratly Islands)**

41 **The Purloining of Envelopes**

54 **For a Staging of Jean Genet's *The Balcony* in 2007**

114 **"Of Simulation and Dissimulation" by Francis Bacon (Published 1625)**

119 **El Proceso (The Process)**

136 **After the Chromopolitical Revolutions of 2005**

142 **Blast Footage: Operations and Apophenia**

176 **"Actually, We Found More Than One Pulse, Sir ... " (With Ed Keller)**

192 **On Deprofessionalizing Surgery**

Foreword: Another Part of Speech

We know that as soon as communications leave our lips or fingertips they are immediately diced and rearranged into information packets better suited for streaming digital compression. And trained to sit up in front of screens, we wait for it all to be retranslated on the other end into the language of our babyhood. We say that it has been "unscrambled," as we point to identifiable things and declarations settled back into familiar narrative forms. So when we try to describe the world, we don't really describe it within the syntax of its own operating systems.

But with this collection of texts, it sometimes seems as if our imagination is finally allowed to rehearse some of those other orders and codecs that are dark to our storybooks. Itself an outcropping of other languages and logics, *Dispute Plan to Prevent Future Luxury Constitution* is a title found somewhere in the author's travels—somewhere where it is probably still earnestly issuing its directive. Any honest plunge into the globalizing world moves through a blizzard of similarly dark evidence recombining on its own into increasing hyperbolic mixtures of candied fairy tales and primitive brutality. The most serious scholar realizes that their footnotes—if unleashed from the dreary chore of corroborating a sensible argument—have a natural tendency to float freely and reassemble into a kind of footnoted fiction or Hollywood faction. And if the evidence doesn't quite exist, it takes very little to make it more true than real.

So the texts become another medium of research. Moving between nanotechnologies, tattoos, an IT campus in Kazan or territories like the South China Sea, orchids become urbanists, imposters offer fictional white papers, children become

robotic surgeons, and Jean Genet, Rem Koolhaas, Carl Schmitt, and scores of others mill about with fictional characters or fictional versions of themselves.

Routed, or packet switched, through multiple time zones, layovers, and networks of ideas we are occasionally allowed to collapse in a hotel room. The world outside is a slow-moving disaster, room service is coming, and the TV is playing a superimposition of *Syriana* and *Daybreakers*. (By the way, as part of all this careful research, we find out we were right all along about Philip Johnson. He really was ... is a vampire.) In our own state of suspended animation, it is not clear whether a familiar aroma or a gentle arrangement offer a clue or only an anesthesia. Or maybe all of these pages are just the streaky afterglow of overexposure, simultaneity, and the exhaustion of looking for meaningful patterns.

The narrating voices are often attracted to cinematic, sci-fi tropes and locutions, and occasionally we could use some help from the boys down in crypto. But with the anomic or heartsick heroes of the genre mercifully kept to a minimum, the potential beauty of being in this colloidal soup is its non-sense—the non-sense within which humor and silliness more easily flower. And along with any one of the protagonists, we are hopefully the butt of the joke. Flown over to make incisive remarks or properly reset epistemes with an analysis of Kojève, we can yet again be found striding purposefully and gravely toward another pre-boarding slapstick.

But swimming in this matrix is precisely where we want to be. Remember the fictional prologue of Marc Auge's *Non-Places* (1995)? "Pierre Dupont" moves through the spaces of airports seeing to the rituals of tollbooths, ATMs, passport control, duty-free shopping on his way toward cabin

pressure and solitude. After page six, you flip the pages back and forth and wonder why the story suddenly gives way to somewhat more conventional academic theory. Since then, we have spent much more time examining that repeatable matrix space, learning about its surprising political powers, the ways in which it is probably not a blank place of emptiness and solitude.

Instead we might contemplate this space as the materialization of several operating systems, constructed in the syntax of information flows rather than architecture conventions. It is itself information, and, as is increasingly clear, it is embedded in routine forms of violence for which our bombastic theories provide no immediate diagnostic. For the architect, beyond shaping silhouettes is the necessary skill to detect what the spaces are *doing* in all their shifting disguises and working protocols. We no longer want a story with fixed names and plots but rather the staging of an encounter or immersion in which to test our reactivity to a stealthy world. This is architecture theory in another register or aesthetics in another part of speech.

—Keller Easterling
Professor of Architecture, Yale University

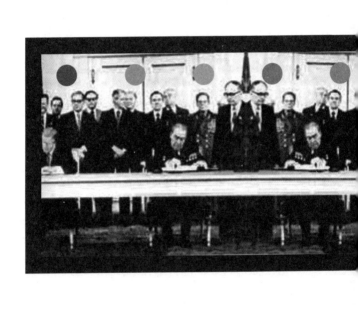

The Orchid Mantis of Sanzhi

Many of you are familiar I should think with the Sanzhi Pod City near New Taipei City in Taiwan. This future city was late for its own birth, which was in 1978. Originally planned as a vacation resort for US soldiers, the project was doomed by a series of mysterious car accidents, and abandoned in 1980. The future lasted only two years.

However, when demolition work began in 2008 it was discovered that not one but five species of Orchid Mantis, as yet unknown to science, had overtaken the ruins, and multiplied to a population of an estimated ten million insect inhabitants, above ground, underground, inside the structures, in between them. No one knows how or why.

Etymologists observe that the unintended Orchid Mantis civilization has developed an incredibly complex division of labor, not only within the same species but between different species as well. These include systems for food capture, nest construction, and stigmergic communication between individuals and groups that have never been observed anywhere else before.

The appearance of the mantis coincided with the proliferation of new subspecies of orchid flowers, which the insects resemble and from which they get their name. Orchids don't usually grow in this part of Taiwan, but today they thrive in the unusual labyrinthine cold and darkness provided by the mantis' own architecture.

The Future City is not for us. The Anthropocene, the reframing of the earth in the image of industrial modernity, will be short-lived, a geopolitical instant more than a slow geological era. Humans are vanishing even as their aggregate biomass continues to swell. Their cities are not their own. They are building habitats for other forms of life. Humans are

the tools wielded by those other forms. We are the robots for future insects.

The extraordinary architecture of Sanzhi—that is, the systems built by the Orchid Mantis on top of and in between the UFO pods—has become in a short thirty years a precious future-archaeological resource. It is not a failed future, but a successful one. It is our future. We are already its present, we who are displaced by the Orchid Mantis.

The Role of Megastructure in the Eschatology of John Frum
(On OMA's Master Plan for the Spratly Islands)

September 30, 2001

The South Pacific Ocean (which some call simply "the Ocean") is composed by an indefinite and perhaps infinite number of geometric configurations with vast planes of salt water in between, surrounding very low carpets of sand. Among these are the Spratly Islands, claimed by no less than seven countries: China, Malaysia, the Philippines, Brunei, Indonesia, Vietnam, and Taiwan. From any of the Spratlys one can see, on the interminable horizon, the upper and lower registers of Chinese hegemony. The distribution of the populations is variable. Twenty-thousand migrants and five languages per port, these are the land-bound sociologies; the height of their buildings, from floor to ceiling, scarcely exceeds that of a normal bookcase. One of the occupied archipelagos leads to a narrower chain of micronations, which opens onto another floating plateau of scientific equipment monitoring, in real time, the metagenomics of plankton, each device identical to the first and to all the rest.

To the left and right of the archipelago there are the otherwise identical capital buildings of two defunct kingdoms (one called the "Kingdom of Humanity"). In the left, the appointed legislature was known to work and sleep standing up; to the right, sitting, to satisfy their fecal necessities. Between the two capitals, above ground, winds a spiral stairway, which today sags abysmally overhead in some places and soars upward to remote distances in others, consuming a sunburnt canopy. In the hallway of the overhead stairway between the two, there is a non-reversing mirror that reflects all personal appearances so that its viewer sees oneself as truly seen by others, and not the lateral inversion presented by a normal mirror. Anthropologists have

inferred from the positioning of the mirror that the still-ongoing decay of the dual indigenous kingdoms is to be taken as a profound measure of their success (if it were not, why this requirement to make the illusion of reflection more optically accurate?). I prefer to dream that its dirty, fingerprint-smudged surface represents and promises another absolute reversibility, working itself out through an architectural drama of legal authority situated as funereal diorama. Inside the equally dark twin royal chambers, artificial light is provided by glowing plastic fruits that in no way resemble lamps. In each room, separated by the sagging aboveground stairway, there are two of these, transversally placed. The light they emit is insufficient, flickering, and loud.

July 10, 2006

This trip to Java is to collect research for a chapter that I will write for a volume edited by colleagues in London on "transnational theology and political violence." My contribution will analyze the 2002 Bali nightclub bombings and whatever I am able to assess as the current state of things in this, the largest Muslim country in the world. My hypothesis, at least as I set foot on the ground, had to do with (1) the pacific effects of Sufi mysticism on Wahhabism's still-tenuous foothold here, and (2) the role and character of the many English/Bahasa Indonesian websites and online forums that operate parallel to the official civic space of the Mosques. The editors have managed to cover my expenses with a cultural grant from an official at the Dutch Consulate in New York who grew up in Indonesia in the years after its independence and, therefore, still considers the island chain to be

within the expanded portfolio of the Netherlands' diplomatic mission. Tomorrow I will interview some of the remaining relatives and colleagues of the spiritual agent of the Bali attacks, Abdul Aziz, better known as Imam Samudra. I have read a Google-translated version of *Aku Melawan Teroris* (I fight terrorists), his autobiography and jihadist manifesto, which became a bestseller across Indonesia during his trial. My editors once considered translating long sections of it to include in the volume, but the prose was so arid and self-aggrandizing that to do so seemed like an additional act of violence in its own right.

Today, however, other news has arrived. Beijing's new master plan for the Spratly Islands is to be designed by the Rotterdam-based studio Office for Metropolitan Architecture (OMA), known in China and Indonesia mostly for its iconic CCTV headquarters and its burned-out homunculus, the Mandarin Hotel. Local analysis of the news is fretful. The *Jakarta Post* writes, "the Chinese occupation of the Spratly Islands was never completely unexpected, but as valid territorial claims had been made on them by so many different sovereign states, the sheer scale of planned development must be seen as well beyond the worst case scenarios feared by Manila or Jakarta ..." The *New Straits Times* adds, "The US State Department loudly identified the conflict over the Spratlys as a potential trigger point for military action in the region as far back as the mid-1980s and did so again with a widely published pronouncement on the danger in 2004." When I was first in Indonesia in the mid-1990s, I learned how unambiguously the Spratlys represented, even as a symbol untethered from real geographical experience—they are seldom visited by civilians—a trembling fear of Chinese regional hegemony, and the physical force thereof.

One journalist spoke to me of that force with words that translated as "volcano," "sun," and "earthquake."

The other Americans squatting in Jakarta hotel bars were quick with predictions, but all seemed to have forgotten that it was our military that divided up the Ocean's islands into provisions and micronations in the wake of the Wars of the Pacific Theater. It was a foregone conclusion that there would be a showdown of some sort, fought on the naval glacis or with the slow martial arts of mixed-use development; perhaps China versus the other six claimants combined. But what about Japan? Should China prevail, it was prophesized, then ultimately no claim on sovereign geography anywhere in Asia would be truly guaranteed. Even with such momentous expectations, none of them could have, and indeed did not, foresee what would ultimately result from China's ongoing capitalization: this megastructure.

July 12, 2006

I am awake with jet lag well past dawn, my research notes scattered and plastered across the ornate, oversized hotel room, adding to the neo-miscellaneist decor. I am days early for my first meetings and I find it impossible to focus on my writing, or on mentally reconstructing the Manichean politico-theological zeitgeist of 2002. The Spratly project is an interrupting omen. To clarify, I am able to write these notes because I've just received a copy of the OMA project and proposal book as presented to select members of the Chinese press, and I assume to the actual clients. It must weigh ten pounds. The sender is a former American student of mine who now works in OMA's Beijing office. In a seminar in Los Angeles, we

had studied OMA's strategic use of programmatic diagrams as political narrative, particularly the generative section, and he was anxious to pass along this new major example to me, a mentor of sorts. As the enormous envelope arrived at my hotel, and as I signed for the parcel from a courier ominously accompanied by security personnel, it felt like I was receiving secure military documents, or drugs, smuggled cryptographic munitions, secret invasion plans. The thing is, to many here in Jakarta, this giant book may have well have been just that. To my student it was an expert souvenir to show that he had made good.

Despite the fact that this country grows so much of the world's coffee supply, it's difficult to get a good cup, even in an upscale hotel, but I am grateful for the adrenaline anyway. The book opens with a long and precise essay on the anthropological, geologic, and military histories of the Spratly Islands, followed by a comprehensive portfolio of images of other ambitious megastructures, both realized and speculative: Buckminster Fuller, Tatlin's Tower, the Palace of the Soviets, Hoover Dam, Superstudio, Reyner Banham, and, finally, the Great Wall and Foxconn. "OMA's current proposed master plan for the archipelago chain of islands must be understood in the context of this history, which this project closely acknowledges."

The project book goes on, some 500 oversized horizontal pages in girth, and I am shocked to see that it touches on some of the very same reference material as the research that has currently brought me to Indonesia. I cannot fathom how this data may have factored into Beijing's ultimate decision to green-light this enormous investment. The second chapter states: "The skull map now on display in Saigon mimics the infamous map of skulls drawn

from the Tuol Sleng museum at the former high school in Phnom Penh which had been used as a Security Prison 21 (during the Khmer Rouge reign of terror)." This gruesome installation of anti-Chinese propaganda is dutifully debunked by OMA to underscore their clients' true sovereign claim, not only on the islands but the entire ecosystem in their midst as well. I didn't share any of this with the student; that was for a different time.

As the OMA project book makes sardonically plain, Vietnamese claims regarding the islands' historical habitation from the Le Dynasty to the present are factually baseless. The Le people are not only unrepresented by the current inhabitants, they actually *never existed*. "Regardless of the international community's policy positions on the ultimate geoethics [sic] of Beijing and Hong Kong's new developments there, the proposition cannot be seriously entertained that the tens of thousands of supposedly dead and disappeared islanders could have been killed by the Chinese occupation, because it is extremely likely that the islands were actually uninhabited at that time." OMA's conclusion: the map of the Spratlys composed with the skulls of those Le people killed by Chinese and Japanese occupations, now on display in Saigon, must be constructed with heads of the dead from somewhere else. This was my hypothesis too. The designers armed the clients with the necessary rationale to deflect opposition, from both those directly affected by their plans and those with exterior cosmopolitan intentions.

Traffic is light today, and the internet seems almost unencumbered. I take the opportunity to execute some lingering errands. I leave the OMA program book locked up at my hotel. The sky is pink and brown, and the waterway smells like old airplanes, the taxis like durian perfume. I feel settled and calm.

July 14, 2006

My contacts who were to arrange today's meetings with Imam Sumudra's remaining network send word that everything has been postponed. All bets off, or? "Not to worry, but don't tell anyone," they relay. That night, on my way to dinner in the Petamburan area, I see graffiti, in English, on garage doors, on the sides of delivery vans: "John Frum." It occurs to me that I've also been seeing it in Bahasa but didn't know it at the time.

The faint parallel lines between my own current assignment, the nightclub bombing, and what I have been reading over the last day in the OMA project book, eventually make me nervous and sad. There are islands and there are islands, but the two are often confused. This confusion drove the whole Dutch East India project, you could argue. Alone at my table overlooking the street, I remember feeling more than a bit ambivalent, conflicted, eventually drunk on Bintangs. "It is extremely likely that in one hour ... " I say out loud to no one, "the conclusion that I have long imagined will prove that the real cause of the Bali bombing was not anti-Americanism, despite the apostolic claims of its perpetrators, but an anti-Chinese hostility that, on Java, mixed local ethnic rivalry with day-to-day civilizational eschatology." Over tea, I review my own notes, written weeks before, on the main opposition movement to the Chinese mobilization of the Spratlys:

> Which doesn't invalidate interest in the New John Frum Party that has made these retroactive irredentist claims, but rather amplifies it: an inverse messianism seeks to repeal a South Pacific occupation in the name of island culture that quite literally never physically existed ...

The Party has long since spread from its "cargo cult" origins on Vanuatu around World War II ... Isaak Wan Nikiau Jr.'s presence in Pacific politics has made February 15, the old John Frum Day of his immanent return, synonymous with anti-Chinese populist sentiment from Macau to Midway. How many different recipes are there for the tragic history of marginalized, colonized peoples to mix ad hoc geopolitics with populist spiritualism to service the specter of pre-Colonial original culture? Not that many? ... The origin of origins. The body of that specter is a culture that can be venerated as "purified" only through such convolutions, as a projective plan for another post-post-colonial political constitution ... The convolutions of the present say "we shall be what we once were." Atavism as telos. ... But what other examples are there of the irredentist projection and formation (and in the case of Skull Map, literal counterfeiting) of a peoples that are neither subjugated nor annihilated by genocide, but who, archaeologically speaking, never existed in the first place?

On the back of my newspaper, I draw out my own sketches of what the OMA project will look like when complete, based on the initial descriptions in the project book's essay. I wonder how different this will be from the official renders I have deliberately avoided examining. From the *Jakarta Post*: "While Brunei will keep its dozen or so Exclusive Economic Zones, and Vietnam will retain fishing access across a nearly 50,000 sq km area, China's consolidation of these satellite holdings will be essentially complete." In essence, OMA confronts the territorial spread of the Spratlys' 750–1,000 islands and sea mounts and, instead of attempting to "resolve" the

geographic and jurisdictional complexities of the islands, they will instead directly merge them into an artificial mega-archipelago. The islands themselves are already spread across three different natural archipelagos, not formed by a single geologic breaking of the Pacific surface, and so the sprinkling of land above is matched by a fragmentation of the foundation beneath. "Even the scattering of land on water is itself a broken foundation beneath ..."

I outline figures, numbers, calculations, one on top of another, seeing if it adds up, even on its own terms. Beneath the water, above the water. The scheme is both brilliant and absurd. By characterizing the annual disappearance of low-lying sea mounts, and the eventual subtraction of much of the land from the map due to climate change-induced sea rise, OMA claims expertise drawn from the Netherlands' national history of territorial production and defense, and use original Dutch terminologies. The project will essentially invert the figure-ground tableau of pebbles floating on water with two essential moves, (1) further carving the already small islands into equal-sized, standardized units, in some cases giving the rocky interiors of the now deeply striated terrains back to the ocean, therefore making their nodal arrangement more flexible and manageable, and (2) linking these units into a multidirectional grid both under and over the rising sea level. This scaffolding will provide, it is hoped, a kind of oceanic canopy through which the new production and distribution initiatives can draw on the islands' considerable but inaccessible oil and gas reserves, serve the freight, cruise, and sea-steading traffic, and also effectively house the hundreds of thousands of new inhabitants to be imported from the mainland. This strategy is in marked contrast to those of the other competing

proposals that, each in their own way, attempted to address the seven-headed claims of sovereignty over the Spratlys with either an architecture of polynational equanimity (a sort of sea-born United Nations chamber-in-the-round) or one of absolute Chinese consolidation. (The Beijing-based studio, MAD, would have fused Sin Cowe Island and a close neighbor with a several kilometer-long concrete peninsula that would invoke Tiananmen Square itself, as portraits of Mao may have done during another time. Unappeasable.)

 My room is black and blue and the pillow feels so cold and dry on my face. The work will have to find its own way, as usual. I assume my editors will not only understand but will also welcome the new directions. More than they paid for, if they can step along with it, and even see where they are going. The muddy light of the wall-mounted lamps leading toward and up the paired staircases was the same as in the beginning. Both head down into the same Ocean but from different entry points, both lead back up but toward different exits. There is no reason to assume one has to be the other. This is what made it possible, over all these hundreds of years, to formulate something like a general theory of the formless and chaotic nature of the islands' intricate and shallow political stakes. Every sensible line is not a straightforward statement, and there are leagues of senseless cacophonies, symbolic jumbles, misunderstandings, unadorned brutalities, and incredible violence; none of it and all of it is encrypted, and it is still right there without veil or explanation or justification. The light is formulated by the dead, who, one supposes, could be staying at the hotel at this very moment, viewing together the slums that will become a parking garage and then a slum again later this year. Writing the present state

of humans and things and phantoms, in the districts where young men would once again prostrate themselves, is what they do. Kissing pages and turning in certain directions at certain times, there is nothing really for them to decipher, per se. That's the wrong word, as it turns out, maybe. It is all the epidemics, fake heresies, and warlords from the television. Perhaps I am just old enough to deceive myself, but I think the whole lot is about to be burned alive without the archive enduring. It is utterly corruptible. The same ideas and images as before, just as I dreamed that its fingerprint-smudged surfaces can point to another absolute reversibility, working itself out through theaters of authority's set pieces and stage sets, and through shadow puppetry in the twin chambers illuminated still by fruit, with all the rooms divided by elevators and stairways, the grinding hum they emit like the sound of people talking.

July 15, 2006

Today's New John Frum movement has never actually threatened to use bombs to disrupt Chinese development of the Spratlys, but has explicitly linked this choice to their opposition to the French nuclear tests that first brought them to the world's attention. OMA's own analysis also makes a succinct and linear correlation between Frum's history, the "bomb" tactic, and the planned future of the island chain. OMA presumes that the namesake, John Frum, must have been one of the many American infantry who occupied Vanuatu during World War II and who may have had an important role in the clearing of the island, in building the many cargo and troop landing strips, or, as has been suggested, in the actual distribution of real cargo to troops

or islanders, as if he had some mastery over their appearance. "John From" Kansas or wherever. However, given the extensive "cargo cult" landing strips that the Vanuatuans built after the war, ostensibly to coerce the skies to land more cargo and which might require "John Frum" to return in order to manage the sacred logistics, the alternative hypothesis is that "Frum" was not a Westerner at all (unlike in the Prince Philip cults) but was himself Vanuatuan and appeared well before the war began promising not a return of American or Japanese bounty, but a cleansing of all outsiders from the island. Only then would the islanders be able to amass their own true wealth. The bounty brought by the Americans suggested that this was immanent, even if it meant suffering their presence for a while. Today the Frum graffiti is directly tied to a potential bombing campaign, which the movement articulates in rich prophetic detail, but never explicitly links relation to the Spratlys, as this would get them included on official lists of terrorist organizations. "Bomb" is instead presented as a symbol of the Frum political theology of irredentist cleansing, which in turn is how the Spratlys problem is framed by the movement for its widespread audience of sympathizers. No direct threats are made, but the chain of pedantic association is unmistakable.

Instead of playing down the Frum threat, as other competing studios did in order to calm the nerves of Chinese officials who had indiscreetly let it be known that they saw the scope of the development as a security risk, OMA instead played it up and used it to their advantage. The flat lattice would connect the hundreds of regularized specks of land into a vast network, having the effect of increasing inhabitable space by several orders of magnitude. It was, they argued, the only way to establish

a development capable of sustaining the scale of logistics programming that the project demanded without also providing clear monuments, symbolic icons, and critical choke points that, if bombed, would provide the New John Frum Party (or indeed any other anti-Chinese entity, from Taiwanese independence groups to Open Internet activists) a clear point of leverage. ("Defense through obscurity, and obscurity through decentralization.") OMA repeats, without typical irony, the apocryphal example of early- to mid-1970s US internet, which linked points between California and Utah, and the SAGE air-bomber early-warning system architecture on which it was based, as a network topology that would provide massive redundancy if ever attacked. The story goes that if the Soviets were to bomb any one node, then the surviving nodes could handle the rerouted traffic. The principle is basically sound, and is as true of neural networks as it is of shipping lanes, but their historical example is inaccurate. Nevertheless, OMA explicitly applied this defensive topology for the masterplan and, in doing so, assured the Chinese that they could continue to build and expand the development as they wished without fear of terrorist attack; not because it was an impenetrable bunker, but because no single tower fallen would strategically or symbolically affect the claims that the Frum party might hope to claim with such an attack. It would be a centerless city with no absolute critical points, and one which can easily subtract attacked zones from its self-healing program, effectively making the "Bomb" visions of the New John Frum Party preemptively irrelevant.

It is startling to think that this rationale may have helped to finalize the allocation of tens of billions of dollars to construct an artificial archipelago in the South China Sea. It is disturbing

for its jaundiced and schematic view of history, and for the hubris and cynicism with which it assigns a role for architecture in the governance of these processes. Unlike the Bali bombers, the New John Frum Party's initial interest in the Spratlys was not rooted in the regional politics of counter-managing China, or in China's bullying of its neighbors. As indicated, it became visible as a leading voice in the outcry among South Pacific nations over France's 1995 atmospheric testing of nuclear bombs near Tahiti (~6,000 kilometers east of Vanuatu, itself another 6,000 kilometers east of the Spratlys). The OMA project book does mention this, and its citation of this event in this particular context is both surprising and provocative in ways that raise the stakes on what is to be won by their megastructural intervention. It is not just about defensibility. The "bomb," small or large, has been a technique of the state—of its formation and its deformation—for centuries. In my own research for the essay I came here to write. (Did my student read this work? Did I mention it to him? It's pretty impossible.) I have linked the Tahiti nuclear tests to moments in the Janus-faced career of the bomb as a means for state authority to carve itself into space, as well as the otherwise uncontrolled, violent refusal of that authorization.

The rain stops, or perhaps it stopped a while ago. I search for and reread the relevant sections from my drafts. "On July 25, 1995, a small handmade bomb ripped through the St. Michel RER station killing several, and turned the center of Paris into a temporary triage zone. Responsibility for the attack was ultimately claimed by several Islamist groups in retaliation for the French cancelation of the 1990 election results in Algeria, which saw religious fundamentalist groups defeat the French and

military-backed civilian parties, but which disallowed them from ever taking power."

I compare the two documents. The project book states that, "the bomb [in Paris] represented an attack not just on the specific French state to meddle in affairs of its former African colonies, but upon the authority of any state—as opposed to religious law—to legitimately organize the affairs of a society." This could have been lifted from my own text. "To attack the authority of secular governmentality itself, the bomb was placed in the center of the Center, the middle of Paris, the capital city, a violent profanation of the secular sacred space of the state." But the trajectory of terrorist architectonics works equally for the state as against it. OMA also links the RER bombs to the nuclear tests. "Almost simultaneous to this employment of micro-explosives as a technology for the spatial erasure of the French state was the deployment of macro-explosives for the reiteration of that state's authority to possess authority and inscribe itself upon the terra." Blah blah, and then they connect it up. "Later in the fall after the Paris bombs, between September 1995 and January 1996 to be exact, in a particularly nasty return of the Gaullist project of Francophone nuclear sovereignty, the waning Mitterrand regime exploded several nuclear test bombs over the Mururoa atolls in the South Pacific."

OMA then goes on to quote the New John Frum Party's own breathless analysis of the French explosions, which is still published, in a weird translation, on the movement's website, dated 1997: "The role of the bomb to authorize both of governments and the true soldiers—from Hiroshima to the WTC—contain multiples of contradictory functions. In the name of defending of the military discreteness of the western state, which in another forum trips over

itself in its haste to dissolve into Eurocapital [sic]." They mean to refer here to the 1993 WTC bombing, to be clear. The 1995 atomic tests were met with protests in the Pacific from across the political spectrum and nearby Papeete was rocked by weeklong waves of riots. But in France the nuclear tests were covered in the French media by perfunctory, matter-of-fact announcements in both public and privately controlled media. The message of the tests was a straightforward declaration of the right of the French state to make declarations on its own behalf, of its independence and singular capacity to act *as* a state, as a collective agent in a world governed *by* states, as opposed to corporations or religions. The uneventfulness and taken-for-grantedness was the point. Meanwhile, at the same time, on September 29, 1995, Khaled Kelkal, the twenty-one-year-old Franco-Algerian suspected of being the bag man in the St. Michel/RER bombing, was gunned down, kicked, and shot again on live television, many times if one counts the incessant replays.

July 17, 2006

I answer a knock on the door: my breakfast on a huge, loud tray, underneath a giant tablecloth topped by the *International Herald Tribune* like a flat bow. I see that another public decency trial spellbinds Singapore, another mail bomb has gone off in Kuala Lumpur, again in a travel agency, and that somehow and for possibly sinister reasons, bacon has again been added to my order. Who is the wholesaler of bacon in the largest Muslim country in the world? There's another knock on the door, and I think about not answering it. The porter hands me a huge stack of newspapers. I must have asked for these at some

point to check on the coverage and reaction to the Spratly project, but I don't remember. I check my e-mail and find a long, weirdly informal letter from my former student:

> You have to understand that Rem completely understands how this project is being received in Jakarta. You must be reading some scary things … You have to understand that he practically grew up in Indonesia. He moved there when he was like seven years old, which must be 1952 or so … So he saw the country being born after its independence from the Dutch which meant his own father … Imagine how that would affect your thinking about the world if you were a little kid. I think it has really shaped him and this project, whether you can believe it or not, is part of dealing with that and doing what has to be done anyway … I don't know what the Chinese think, and definitely Rem is suspicious. I mean, come on. … This project may seem too ambitious, but really it's not. It will work in ways that I am sure the people who are so scared can't possibly imagine now. Look, sometimes he goes too far—he's the first one to admit it.

He goes on repeating everything I already know from reading the project book, and even draws analogies between certain maneuvers and ideas that he first encountered in my writing, apologetically, enthusiastically. Then he repeats himself in regular centripetal patterns until the letter ends. My stomach sinks. As an add-on, he nonchalantly discloses something that I didn't know and I'm certain is not widely known, regarding an earlier late-1970s incarnation of OMA and their involvement in a planning project that was sponsored in some way

by French-Algerian financiers backing the Khmer Rouge and brokered by the infamous Thai-French attorney, Jacques Vergès. He hints at this and moves on. It's all too much. It's not a conspiracy; it's a revelation of childhood abuse. The e-mail ends with an invitation for me to attend the groundbreaking ceremony in the Spratlys as a supervising dignitary. If you can keep your head when others are losing theirs. The skull map. I close my eyes, and press my fingertips into my eyelids, watch the spiky flickers trickle and trail across the warm insides, breathing slowly, concentrating on them as they move closer and further away in their own miniature cosmos. I hope to fall with their zigzagging descents.

July 18, 2006

I can barely sleep at all for the third night in a row. I dream of elephants staring up at me as I hover above them like a helicopter; waves of tall green grass blown violently all around them. There is still no word from my supposed contacts. I decide to allow myself to fully unfold the oversized map of the project's artificial archipelago, because it is a hot pink dawn again, and so I slide everything off of the dining table in my hotel room onto the carpet. The massive network of curves stretches from one end of the South China Sea to the next—circulation patterns of permanent inhabitants, temporary workers, temporary executives, the data packets flowing through the structure's huge-capacity fiber-optic cables, the logistics of real goods, internal and external transportation, the tracking of paper dollars and yuan through near-field communication systems—everything—is modeled by complex fluid dynamics measurement equations.

Incomprehensible maths annotate the fractal soap bubble composition. I read that all flows—human and inhuman—have been simulated with Lagrangian and Eulerian equations to an unreasonable and absurd level of confidence and predictive granularity. Any and all of these design issues are largely initial state problems, and so this degree of simulated prediction and control cannot possibly be real. On the page, it is math as heraldry. Architectural programs are both strictly partitioned and promiscuously interwoven, Euclidean and hyperbolic geometries collapsing upon one another: container sorting, manufacturing and assembly, long-term asset storage, banking and data services, all coexist with resorts and prisons. They are arranged with an inspired and desolate combination of maniacal algorithmic precision and totally arbitrary cynicism.

The artificial archipelago's fuzzy topos is based on research in global internet packet routing by Dmitri Krioukov. His work models hyperbolic distances in packet routing across the earth's surface and confounds commonsensical relationships between nodes in the tangled lattice of cyberinfrastructure and traditional national geography. Sometimes the shortest distance between two points is determined by a smart packet heading in what appears at first to be the opposite direction from its intended recipient. Legacy networks essentially required putting a kind of "map" of the entire internet address space into every router, such that each believes itself to be aware of the entire network at once. The address tables require constant updating, and, as a whole, each router is asked to perpetually overthink the optimum path of every packet entrusted to it. Krioukov devised an ingeniously simple method of giving a sense of *direction*

to the lowly individual packet itself, such that even the simplest unit of information doesn't need to know its ultimate career in advance of being sent, and no gateway needs to recalculate the itinerary of every message it shuttles. Packets move in the general direction of their destinations, however global or local that generality may be when they are far away or nearby to it. The result of these two modifications (hyperbolic versus Euclidean distances and building "greedy pathfinding" into individual packets) could realize perhaps an order of magnitude increase in global data throughput, should such ideas be fully and properly implemented. As it stands today, only a fraction of publicly accessible networks use these methods to their potential, though most large corporate infrastructures (including Google's own internal networks) have been based, at least partially, on Krioukov's methods for some time. I myself know next to nothing about it.

OMA's essential insights are:
(1) To treat the masterplan for the Spratly artificial archipelago as a regional scale meganetwork capable of intensive amputation and regrowth.
(2) To treat the distributions of human program and nonhuman program as interchangeable packet layers.
(3) To imbue packets with a precise quantum of sovereign mobility.
(4) To privilege the geometries of hyperbolic distances in all ways practical over Euclidean distances.
(5) To elevate this privilege to an ordinal principal of militarily defensible physical and political geography.

More knocks, more breakfast. More newspapers, more bacon. No word from contacts. The Bali bomber's remaining confederates are not enthusiastic to account for themselves in an interview, I guess. The court cases are too complicated and they are already turning on each other. Uniformly fragmented island atolls are rendered by dynamite into standard-sized unit positions in a grid and installed into another new ordered oceanic surface. Hotel shower and hotel toilet, hotel sink, hotel bed, and in the South China Sea, plankton are captured and their genomic evolution modeled in real time against the master image of climate variation. The project's most iconic images are of Poincaré geodesics and half-plane models: those fractal soap bubbles again scaling infinitely dense or opening upon whatever edge they are pressed. Now there is "third order heptagonal tiling" where before there was only ground plane and water and old military maps with naive naval zones crisscrossing the island spread. As the ethics of material and materialism, this grid is absorbed and reprocessed into what it had been all along, under-noticed, that is, an ambition less for the line than for the knot and its avoidance.

July 28, 2006

The stupidly methodical tasks of writing and of editing distract me from the present state of things and from how they are designed and governed for real. I am certain that everything I might try to communicate would quickly negate itself or turn its subject matter into a pun. I read the words on my page, "I know of places where young men prostrate themselves before old buildings and kiss their surfaces

in an unsettling manner, but they do not know how to open a single door. Outbreaks, sarcastic heresies, peregrinations which inevitably degenerate into sophistry, have decimated the populations there. I try not to spend too much time writing about suicide bombing, more and more frequent with the years, because others have so jealously staked it out as their territory for interpretation." Perhaps a postponed but inevitable exhaustion confuses me, but even if the human species is about to be extinguished, the project supposedly will endure: illuminated, solitary, geometrically infinite, perfectly motionless in its speed, equipped with precious volumes of useless inaccessible secrets. The new international terminal at Soekarno Airport is quiet and sunny, an enclave of abstraction and the serene mobilities it promises. Like all enclaves, it is a version of utopia. Pre-boarding for departure is announced and we self-segregate according to our relationship to the mode of mobilization, ceremoniously repeating, in miniature, the procedures of the outside world to which we owe our presence.

Into a new blank document file, I have just written the word "impossible." I have not pulled this adjective out of rhetorical habit, but looking back from some perspective on its ultimate demise, is it illogical to think that the world is itself impossible? Those who would advertise counterarguments about Being are also those who postulate that, for all the places close at hand, the corridors and stairways and axonometric hexagons cannot justify us even to ourselves because they are too faraway and too foreign and not of the here and the now. Those who make such claims are much, much worse. And then what? Is it possible that the number of combinations of these systems has no limit, that a site condition has no ultimate ecological purchase? I hope to plot a

solution to this some day. Instead to ask, is the Turing machine heavier than an airplane of immanence, neither unlimited nor cyclical? If a perpetual tourist were to cross it by ship in any and all directions, after centuries he would see that the same architectures were repeated in the same disorder (which, thus repeated, would be an order, perhaps *the* order?). My insomnia is soothed by this hope.

Just before taxiing onto the runway, I scan one last e-mail from my former student. It includes clippings from a Beijing-based website documenting spectral appearances of "Koolhaas" at the construction site, wrapped in dark glasses, hidden behind officials, barely visible to cameras. In later posts he is shown in whiteface, arms waving above his head in incantation. In fact many such figures are lined up, one after the other, each in a white suit, in white face paint, in black sunglasses, and posing with the workers. Is this Frum? My student continues to speculate on Koolhaas's childhood in Indonesia, his possible daily routines, hobbies, traumas.

July 28, 2007

This carnivalesque satire of the belly of the architect is not the only form of grotesque realism that the project would endure or enforce or withstand or perpetuate. Its mania and rigor could not immunize it from being reframed by counter-narratives. You are familiar with the "documentary" film *Archipel Kepulauan*? Beside the obvious, the film has another unusual and uncomfortable link to the messianic irredentism of the New John Frum Party. Frumists claim that some of the workers shown in the film— crushed underneath collapsed building sites, thrown off boats into the sea, stacked like fish in floating

prison/hospitals, dismembered for sport by bored, drunk construction teams—are descendants of the long original Le islanders. Would that it were so. In fact most of the laborers depicted (variously working, smiling, or dying) are from the territories of Sarawak and Madura, as the film reveals despite itself. Frumist websites freely use collaged snippets from the film as source material in the creation of fantasy terrorist attack scenarios, edited into often-lavish short videos and distributed openly on American and Russian social media sites. These sorts of quasi-fact, quasi-fictional fantasy attack plots (a hack genre known as "Bojinka") make extensive use of *Archipel Kepulauan* as cornerstone source footage. So while the film makes no reference to Frum theology, and in fact the filmmakers have now disavowed any association, the film nevertheless is a canonical resistance text for the movement, and continues to circulate through informal networks of hand-traded flash drives. Or so I am told. I didn't encounter any such thing myself, but I am possibly the last stranger in the city who is likely to be entrusted with the reception of such a thing.

Except for the dozens of new and old airstrips striating the sporadic open lands, and the largely symbolic megasculptural troop barracks that Brunei has used to ensure is EEZ claims, the Spratly Islands look much like they have for decades, and in most areas, as they have for centuries. Despite the violent scope of the project plans, today the archipelago is still remote and largely lifeless and empty of buildings. Renders from OMA's master plan already adorn the covers of new Mandarin-language tourist guidebooks and fill up multiple different user-generated layers on Google Earth. The now iconic hyperbolic lattice system, both submerged and above water, has already been repurposed in

Second Life, the new criterion of architectural cliché. The Skull Map of the lost Le people on display in Saigon, however surely counterfeit, is at least tangible and physical. It is a real fraud, not a fraudulent real. Construction on the OMA project has been delayed for three years as of now, and it is uncertain when, indeed if ever, the project will be fully undertaken and completed as planned. Baseline projections on sea-level rise with a high degree of predictive certainty all but assure that 10-15 percent of the island land will be underwater by the end of the next century, while the more extreme projections that presume the exponential climatic effects of multiple positive feedback loops amplifying one another would put that closer to 20-30 percent. China's absorption of the Spratlys into a new logistical exo-continent, along with OMA's synthetic topology, may only succeed to the extent that they can also provide for adaptation to ecological transformations that cannot be realistically predicted before construction begins. An initial value problem once again. If this is so, then the project may be an ingenious solution to a very different situation than the one it was originally assigned. Or equally possible, it can be recommended on its own account, even before its completion, as an exotic ruin of failed governance and regional superpower overreach. Nevertheless, it has already succeeded as a geopolitical ploy, through the sheer presumption of momentum, to silence the competing sovereign claims over the Spratly Islands by neighboring countries. Malaysia has even formally recognized the entire chain as part of China's extended territory, based, in essence, on the presumption that the OMA Plan is the inevitable future of the archipelago. And so even before the megastructure is built, it already is so.

August 11, 2008

I did eventually meet with the acquaintances of Imam Sumudra, introduced to them indirectly by contacts made with Frumist groups interested in having their side told through me, a channel they mistook as a Dutch journalist. We disappointed each other, I am sure. At that time it was also hoped that some insight into basic mysteries of the social—the archaic origin of the state and of the time of geography perhaps—might be found. It is or is not coincidental that these grave concerns could be demonstrated as and through architecture. If the language of the stone is not sufficient, then the multiform Plan or the solemn grid will have produced the diagram. Since the Japanese surrender on board the USS *Missouri*, nearby designers, politicians, and terrorist functionaries have contested the Plan. There are official actors of sorts. Supposedly utterly unrelated in purpose, but before, during, and after my interviews with them they all present themselves to me in the exact same way. They are opponents who have become one and the same through the friendship with their inverted, interwoven paranoias. I have witnessed them in the commitment of their purpose: they appear exhausted by their work, they recount, by way of endless footnotes within footnotes, of renewed commitments to personal and collective purification, and to communities and insurrections to come that will, by way of their divine anonymous violence, resolve the constitutional contradictions of the ongoing stalemate of an unbuilt project that may hold the key. They talk with their admirers of good works to come, and sometimes they spend hours picking aimlessly through their feeds looking for some bit of information that will inspire and inaugurate their next move

tomorrow morning. They scan for critical events. Obviously, no one expects people such as this to build anything or tear anything down, and yet there the project is, at least partially finished by now.

As was to be expected, mania is followed by flamboyant depression. Some means, some practical violence of the state, or against the state, for the project, or against the project, somewhere somehow, would turn the tide in their favor, they each invariably conclude. In the end a small, blasphemous Frum sect originally from Midway Island suggested that the opposition should cease and that all Islanders, including the Chinese engineers and the Dutch, British, and American architects, should jumble the Plan until they have constructed, by the probabilities of fate or chance, another megastructure that would absorb the intentions of Beijing as well the eschatological promissory aspirations of the New John Frum Party into one. "Can this not be Babel?" they ask optimistically, in not so many words. The Chinese issued damning orders on them, as did the mainstream Frum resistance. This sect, the last of them, disappeared—at least from my view. On occasion I have seen what I take to be their scribbled graffiti wasting away in the public comments sections of the project's waning journalistic coverage. Despite their sense of doom and defeat, in many ways this is their true solution, at least to what is most important to them, which, in reality, has prevailed. Their composite Tower will be built, and with time, theirs will be that which is honored by decay.

The Purloining of Envelopes

Alexandre Kojève was a Russian philosopher most known for his seminars on Hegel at Paris's École pratique des hautes études in the 1930s. In their influence on the work of colleagues and students, these seminars forever altered the Hegelian flavor of the century. From these seminars, the figure of history would manage universal states and universal societies that un-cinch the modern from whatever-it-gives-way-to, and the casts of millions whose heroics dramatized all the finalities of resistance. Kojève's students and colleagues included Bataille, Lacan, and Merleau-Ponty, and through them Foucault, Derrida, and their correspondent disestablishment of Marx and Structuralism. On the right, he developed long and productive discussions with Carl Schmitt, Allan Bloom, and Leo Strauss, and through them to American neo-conservatives, from Fukuyama to Wolfowitz, and their unfortunate mis-projections of a final, synthetic universality. Others have also made the claim that Sayyid Qutb, who founded the Muslim Brotherhood, an important precursor to al-Qaeda soon after studying abroad in Colorado in the 1950s, also drew inspiration from Kojève's Hegelian reading of modernity's decadent triumphs, and the need for a heroic man-of-action to realize and/or resist them.

We also consider the comparatively more obscure work of another Kojève disciple. Bernard Josephe was hired at EEC in 1965 largely on the recommendation of Kojève, who had himself worked there since just after World War II. Kojève clearly imagined European integration both as a realization of his own Hegelian political imaginary, but also as a nascent figure of the universal state to come. Josephe reported directly to Kojève until his mentor's death in 1968, and then took over some of his portfolio. Josephe had written a dissertation on Albrecht Dürer's magisterial print *The Triumphal*

Arch of Maximilian 1, an eleven-foot woodcut diagram of the emperor's divine right to rule, a vast org chart of authority, which is now on display in the British Museum. Josephe's text made much of the explicitly architectural medium of this political projection. Of specific interest to us is that in his capacity at the EEC Josephe wrote a curious series of white papers in 1977–78, which he picked up on again while at UNESCO in 1989, on the problem of terrorism. In these works, the nexus of architecture, political form, and its exceptional challenges is considered in fascinating, prescient detail, drawing extensively on the work of another of Kojève's correspondent, Walter Benjamin.

In Jospehe's 1977 report to the UNESCO Special Sub-Committee on Political Violence, "Provisions Toward Final Committee Recommendations on the Problem of International Terrorism and Urban Planning and Design," he writes:

> The state is a function of the geographic partition, and its sovereignty is produced in that convoluted and reversible image. ... But the State is not the same as society. What is called the social is inscribed and multiplied through much less definite membranes than geographic borders. As the (social) body repeats its habitual postures, wearing grooves into space, so then does architecture emerge: an indirect artifact of those habits, and a shadow of their postures. What is called Authority is derived from those concrete forms and metaphors, and relies upon them to instantiate its theatrics. ... Architecture is recommended as both the substance and the medium of that authority, itself both the substance and medium of violence.

He continues:

> Terrorism, we can say, is designed exceptional violence; designed for an effect of fear. To redesign the city in response to the terrorist attack on to the city is to escalate the state of emergency into an endlessly vertiginous assignment. ... The proliferation of "provisional" designs put forth to meet this temporary situation. ... But the emergency produced by the responses to terrorism asks designers to accommodate their particular emergencies and to normalize them by their compositions. ... But what is compliance when both terrorism and architecture are, in the best sense, projective delusions, fictions that by their violence realize historical fact?

And finally:

> Conservative or radical or democratic, the proposition of an architectural or urban program is real but also a complex dramatization of other factors. It is a projection. ... Likewise, violence, whether serving the constitution of the law or exceeding it, requires and seeks out architectural mediation. The law needs a body to adjudicate. ... In light of this, terrorism is based not only on illusion and prophecy—like the architecture designed to counteract it—it is drawn into to a paired economy of projection. ... Its substance, its medium: architecture.[1]

[1] These excerpts are from Bernard Josephe, "Provisions Toward Final Committee Recommendations on the Problem of International Terrorism and Urban Planning and Design," UNESCO Special Sub-Committee on Political Violence, Public Records Publication Bureau Archives, Paris. Originally published 1977 (translation from the French is mine).

Interestingly, also found in the same dossier with the apparently incomplete "Provisions Toward ... " report are three different versions of a carefully written list of abbreviations and dates. In the margins of the oldest of these documents (dated 1974) the abbreviations are matched with names. As compiled with the assistance of Adam Bandler, when matched together we see that the abbreviations refer to Kojève himself and four of his most renowned contemporaries.

- WB: Walter Benjamin
- TA: Theodor Adorno
- CS: Carl Schmitt
- AK: Alexandre Kojève
- LS: Leo Strauss

Josephe listed these together in a long column with dozens of rows, and next to them was a another column containing strings of six numbers, written as: two numbers, period, two numbers, period, two numbers. Only after some time did it occur to us that the numbers were actually dates. So what did Walter Benjamin and Carl Schmitt have to do with one another in December of 1930? It was another year before we read an unrelated report by Josephe in which he discusses Kojève's influence across the political spectrum and mentions offhandedly that he once attempted to compile a list of all the written correspondence between these five men. The dates on the list were the dates of those letters.

 Josephe never completed his list, but access to the relevant archives and databases is easier today and so we've attempted to compile as complete an index as possible. That index is below and provides a map not only of Kojève's central

influence on midcentury political philosophy but of the easy oscillating symmetry between its leftist and rightist variants.

All dates written dd.mm.yy

Date	Correspondence
02.07.28	WB to TA
01.09.28	WB to TA
29.03.30	WB to TA
10.11.30	WB to TA
??.12.30	WB to CS
17.07.31	WB to TA
25.07.31	WB to TA
13.03.32	LS to CS
31.03.32	WB to TA
03.09.32	WB to TA
04.09.32	LS to CS
10.11.32	WB to TA
01.12.32	WB to TA
06.12.32	LS to AK
13.12.32	LS to AK
17.12.32	LS to AK
14.01.33	WB to TA
??.??.??	LS to AK
10.07.33	LS to CS
16.01.34	LS to AK
29.01.34	WB to TA
04.03.34	TA to WB
09.03.34	WB to TA
13.03.34	TA to WB
18.03.34	WB to TA
??.??.??	LS to AK
05.04.34	TA to WB
09.04.34	WB to TA
09.04.34	LS to AK
13.04.34	TA to WB
21.04.34	TA to WB

28.04.34	WB to TA
01.05.34	AK to LS
24.05.34	WB to TA
03.06.34	LS to AK
06.11.34	TA to WB
30.11.34	WB to TA
05.12.34	TA to WB
16.12.34	TA to WB
17.12.34	TA to WB
07.01.35	WB to TA
??.04.35	WB to TA
01.05.35	WB to TA
09.05.35	LS to AK
20.05.35	TA to WB
31.05.35	WB to TA
05.06.35	TA to WB
08.06.35	TA to WB
10.06.35	WB to TA
19.06.35	WB to TA
05.07.35	WB to TA
12.07.35	TA to WB
05.08.35	TA to WB
06.08.35	WB to TA
27.12.35	WB to TA
29.12.35	TA to WB
??.??.36	WB to TA
03.01.36	WB to TA
29.01.36	TA to WB
07.02.36	WB to TA
27.02.36	WB to TA
18.03.36	TA to WB
28.05.36	TA to WB
02.06.36	TA to WB
04.06.36	WB to TA
16.06.36	TA to WB
20.06.36	WB to TA
30.06.36	WB to TA

Date	Correspondence
06.09.36	TA to WB
27.09.36	WB to TA
15.10.36	TA to WB
18.10.36	TA to WB
19.10.36	WB to TA
26.10.36	WB to TA
02.11.36	AK to LS
05.11.36	WB to TA
07.11.36	TA to WB
28.11.36	TA to WB
02.12.36	WB to TA
29.01.37	WB to TA
17.02.37	TA to WB
01.03.37	WB to TA
16.03.37	WB to TA
31.03.37	TA to WB
13.04.37	WB to TA
15.04.37	TA to WB
20.04.37	TA to WB
23.04.37	WB to TA
25.04.37	TA to WB
01.05.37	WB to TA
04.05.37	TA to WB
09.05.37	WB to TA
12.05.37	TA to WB
13.05.37	TA to WB
17.05.37	WB to TA
15.06.37	WB to TA
17.06.37	TA to WB
??.07.37	WB to TA
02.07.37	TA to WB
10.07.37	WB to TA
21.08.37	WB to TA
13.09.37	TA to WB
22.09.37	TA to WB
23.09.37	WB to TA
02.10.37	WB to TA

22.10.37	TA to WB
02.11.37	WB to TA
17.11.37	WB to TA
27.11.37	TA to WB
01.12.37	TA to WB
04.12.37	WB to TA
01.02.38	TA to WB
11.02.38	WB to TA
07.03.38	TA to WB
27.03.38	WB to TA
16.04.38	WB to TA
04.05.38	TA to WB
08.06.38	TA to WB
19.06.38	WB to TA
02.08.38	TA to WB
04.08.38	TA to WB
12.08.38	TA to WB
28.08.38	WB to TA
04.10.38	WB to TA
10.11.38	TA to WB
09.12.38	WB to TA
01.02.39	TA to WB
23.02.39	WB to TA
15.07.39	TA to WB
06.08.39	WB to TA
21.11.39	TA to WB
29.02.40	TA to WB
07.05.40	WB to TA
16.07.40	TA to WB
02.08.40	WB to TA
25.09.40	WB to Henny Gurland (and TA?)

Five-year silence in the chain of correspondence, during and just after World War II.

Perhaps the project's conflicts had found other media.

Date	Correspondence
22.06.46	AK to LS
08.04.47	AK to LS
22.08.48	LS to AK
06.12.48	LS to AK
13.05.49	LS to AK
26.05.49	AK to LS
27.06.49	LS to AK
15.08.49	AK to LS
04.09.49	LS to AK
10.10.49	AK to LS
14.10.49	LS to AK
26.12.49	AK to LS
18.01.50	LS to AK
24.03.50	LS to AK
09.04.50	AK to LS
26.06.50	LS to AK
28.07.50	LS to AK
05.08.50	LS to AK
14.09.50	LS to AK
19.09.50	AK to LS
28.09.50	LS to AK
19.01.51	LS to AK
22.02.51	LS to AK
17.07.52	LS to AK
11.08.52	AK to LS
29.10.53	AK to LS
28.04.54	LS to AK
02.05.55	AK to CS
09.05.55	CS to AK
16.05.55	AK to CS
26.05.55	CS to AK
28.05.55	AK to CS
07.06.55	CS to AK
11.07.55	AK to CS
01.08.55	AK to CS
14.12.55	CS to AK
04.01.56	AK to CS

Date	
11.05.56	CS to AK
21.05.56	AK to CS
04.06.56	LS to AK
08.06.56	AK to LS
30.11.56	AK to CS
05.12.56	CS to AK
23.12.56	CS to AK
24.12.56	AK to CS
23.01.57	AK to CS
31.01.57	CS to AK
12.02.57	AK to CS
11.04.57	AK to LS
22.04.57	LS to AK
28.05.57	LS to AK
01.07.57	AK to LS
11.09.57	LS to AK
24.10.57	AK to LS
05.11.57	AK to LS
15.05.58	AK to LS
17.02.59	AK to LS
04.04.60	AK to CS
06.04.61	AK to LS
30.01.62	LS to AK
27.03.62	LS to AK
29.03.62	AK to LS
29.05.62	LS to AK
04.10.62	LS to AK
16.11.62	LS to AK
25.01.63	LS to AK
03.06.65	LS to AK

For a Staging of Jean Genet's *The Balcony* in 2007

> We are millionaires in images of revolution.
> —Jean-Luc Godard, *Ici et ailleurs*

Jean Genet's 1956 play *The Balcony* takes place in an unnamed brothel, referred to only as a "house of illusions," where powerful dignitaries—a judge, a bishop, and the chief of police among them—pay a monetary fee to shed their costumes of power and identities of authority, and to submit to the sweet sadistic abuses of the expert staff. Outside the fantastic confines of the House, an unnamed revolution is engulfing the city and coming closer, closing in. Inside, leaders of men who have closeted their uniforms now realize that, should they leave the House in the uniforms in which they arrived, the mob would annihilate them on sight. In earlier drafts of the script, Genet explored several endings from this point forward in the narrative. In most, the cowardly authorities buy pedestrian garments from the sex workers and staff so that they can escape under the cover of anonymity—a class camouflage—and they do so. The revolution burns further. Political order breaks down more completely, and the staff are held captive in the House with only their imaginations and the abandoned uniforms of the police, the courts, and the church to dress them. Dawn breaks and the fires burn out. The staff put on the robes and ribbons of their previous clients and cautiously venture out, where they soon meet the mob. There, before the crowd, they are visions: miraculously appeared figures of legal, penal, civic, and spiritual authority rising from the desolation of the revolution's wake. One by one, each is exalted and vested with a new regime. In some versions, the action ends there, with the heroine-prostitute, Chantal, becoming the new *fille de la revolution*. In other versions, to my knowledge none ever officially performed on

stage, the sadomasochistic theater of the House turns itself inside out and becomes the grotesque platform of the new regime's proposed constitutional order. In the metaphoric miniatures of the early sections of the play, power is rehearsed in provocative comic inversion, where fantasy and reality playfully change places, and are made by Genet into constitutional techniques of formal sadism and masochism, which become now ontological foundations of law ... hence in some of the most visionary passages, of a new urban plan for Paris.

In Genet's unpublished notes on the later manuscripts, he writes:

> In a malevolent drama, we can find both the erotics and politics of contemporary fears. They have become soldiers of beauty. In this process the images of their dress and bodies merge into abstract patterns. Hallucinating. It is as though by applying a mask, even a feminine mask, they engage in an act of disguise. Thus, we find ourselves at the issue to which their works here refer. Camouflage, itself a topic that people often find interesting ... The common idea of camouflage as something that conceals, hides or disguises the presence of something, e.g., an insect, butterfly, animal or military equipment, is based on the assumption of mimicry. But for mimicry it is supposed that the object imitates its surrounding environment, so as to "fit in" and hide itself from surrounding prey or potential attackers. Thus camouflage in nature is assumed to be hiding something and mimicry is either an offensive or defensive strategy. But this conception of the function of mimicry as camouflage in nature has been contested.

The reader will note a similarity between these sections of Genet's notes and the ideas found in Roger Caillois's famous essay "Mimicry and Legendary Psychasthenia," first published in 1935. Both state that the literature on animal mimicry and organism metamorphosis has made a fundamental mistake in presuming that mimicry-as-camouflage is a universal explanation for all such phenomena. Camouflage may not be the aim of such mechanisms in nature. For his part, Caillois links some of the strange morphological habits of organisms to copy their surroundings to a kind of crisis of identification.

The Plot as Doubling Machine

Once an act of narrative violence occurs, it is already happening for the second time. This complicates any straightforward interpretation of exceptional violence, both terrorist and counterterrorist, that would understand it as simple clashing of forces over the constitution of the right to govern. Rather in the confusion of fictive and real events, the political charge of the projective imaginary is revealed: a previously unpublished interview with Paul Virilio conducted by Catholic militants in the aftermath of 1968; a short passage by Frantz Fanon on the power of pirate radio to inspire fantastic popular fictions about the power of the FLN that far exceeded their real military might; an original or secondary report on Abu Zubaydah's issuance to the FBI that al-Qaeda had targeted the Brooklyn Bridge after seeing it in the recent remake of *Godzilla*; Timothy McVeigh's inspiration to target the Murrah Federal Building through a novel called *The Turner Diaries*; McVeigh's own comparison of his work to that of Bin Laden; Peter Hoefnagels's essay on Atelier Von Lieshout, a Dutch architectural collective that used to fashion itself to a large extent on the RAF and American militias; as

well as sections from Genet's play in which authority trades clothes with the brothel so as to escape the rage of the revolting masses taking over the city.

The speculative character of architecture works as another doubling-in-advance of this doubling-of-the-act. The procedure of its design is the inscription of an image-thought into urban form, and that form first stands as a figure, a model that refers to the discourse of architectonic figuration itself and, only later, after extraordinary social, legal, and economic mediation, is it de-simulated into a physical building in and on a site. The chain of architectural representation moves not from the thing to the image but from the image to the thing, if it moves out of the image at all.

War, and specifically the sporadic outbursts of "terrorist" violence, constitutes itself as a virtual product, one through which the supply chain management of various militia is modulated by demand-chain technologies such as futures markets and prophetic meta-narratives. Formal scenario planning began in the 1960s on the sun-soaked conference tables at the RAND Corporation in Santa Monica, and helped drive the Vietnam War into the ground. Policy Analysis Market, DARPA's attempt at a crowd-sourced variation on the Revelations to St. John or the coming of Qiyamah, run by some folks at Cal Tech in Pasadena in order to manage exceptional violence in advance of itself, to govern its contours and bring them into being, through collective, predictive prophecy and management.

Terrorism is situated in a similar relay for which the real follows in the wake of the doubles that precede it, not only because the terrorist act of anti-architecture, of destruction, requires careful planning in advance, but also because the act is the charge of an imaginary realm de-simulated in ours.

Examples are plentiful. Al-Qaeda built rudimentary versions of American cities to attack in the Afghan desert. Senator Orrin Hatch built a full-scale model of a New York subway underneath the Utah desert to bomb with poison gas. The city of Santa Monica blew up several of its own disused public buses one nice spring day to help plan for the inevitable. This is an architecture of attack in advance of the attack on architecture. It is both a wishful fantasy and a strategy of defense against the realization of potential wish attacks. As much as architecture is an object of attack, it is not just the raw material of incident—a nevertheless magnificent debris of programmatic repetition—it is also the agent of an unfolding drama of symbols, such that to attack its form is also to attack an order that is not only represented by the architecture but embodied by it.

We understand that subjectivity results from the repetition and performance of particular roles, postures, and figures. Likewise, the figural contours of the built environment build that environment though performative repetition, and habitats in turn produce and enunciate themselves through bodies, manifested as habits. As ever, spaces contain and constrain only as much as they stage and generate; they are expressions of bodily form but also express themselves as and through bodily form (prisoner, worker, individual, mass), through habitats (cage, desk, car, desert, bed, corridor), and through the articulation of those habits they are rendered as institutions and as material design culture. The neurological fiction that is the manifest image of our own individual subjectivities emerges from the repetition of particular positions, which themselves emerge in relation to particular architectural surfaces, positions, and dispositions. All the more

reason that the occlusion of the real would become the mechanism of constitutional violence.

After and Around a Critique of Violence

An elemental question: Why does exceptional violence so often act upon architecture, and how is exceptional violence already architectural in its conception? In his essay "Critique of Violence," Walter Benjamin sought a mytho-historical model of exceptional violence and its relations to the law. He differentiates constituent violence (violence that would impose a law by force) from constituted violence (violence that would defend an established governance). From these, he further differentiates, or imagines himself to differentiate, a "pure violence" that would operate outside of any means-end economy, but which would, by its appearance, provide a more fundamental sovereignty of the governed to act as the agent of historical form-giving force. There is of course a messianic imagery in Benjamin's work and the thrust of this text is exemplary of that tendency, as Benjamin seeks to ground an ur-historical morality of violence in an ultimately ungroundable, perpetually deferred, prophetic justice. The distinction of the difference between mythic and divine violences trading garb is a Jerusalem. Its interest is both in the grounding and the groundless, and in a seemingly infinite legitimacy afforded by such deferrals.

What, then, is the state of exception, and ultimately what should be the response of architectural design to accommodate, resist, evade, or augment it? Further, for the logic of dissimulation within which such declarations of exception are made, what are the terms to even enter a debate directly? In other words, because architecture in its many guises plays a central role in hosting these

violences and these deferrals, what is the predicament of the designer to act or not act in the midst of such emergencies, real and imaginary? Architecture is not (only) the expression of power coming from some other (juridical) place. One must ask not primarily how architecture represents power, but rather how it traces power in derived incorporations and disassemblies. The base of that derivation is an exceptional violence that is at once constituent and constituted; it both makes use of extant built form to inscribe itself and, at the same time, is a projective affirmation of an alternate political geography yet to come. That is, terrorism uses the concreteness of architecture as its instrument and target, and at the same time its fictional, narrative logics are themselves already "architectural" in both form and content.

It is in such oscillations between artifacts of the physical and imaginary, located in both architecture and its exception, that simulation and dissimulation are able to configure one another. What emerges is not a resolution of Benjamin's fantastical "pure violence," but rather a reestablishment of a projective deferral, itself the condition of violence in the name of a law (a House) yet to come. The mediation of violence is then something different than its instrumentality, and so the abstraction of an exception and the generalized state of siege inscribed through it are never reducible to one another. Benjamin's politico-theological interest in exceptional violence turned his attention away from how it concretely mediates itself in the physical architectonic event, which is hardly ever a "distracted medium."

The mediation of the abstraction and the siege, between one and the other, can also produce a secondary substance. If the forces of violence are

disembodied before they are fully and finally rendered in the debris, they can cause the broken body of the architecture to appear before the destruction is actually put to work. In fact, forces of violence are derived from these substances: Habeas Corpus, the "law needs a body," and thus a body from architecture. Put simply, architecture—as projection and composition, and simulation and dissimulation—is not only the image of law (of its means and its constitution) but is the very substance of the field of forces that compose enforcement at all. Both substance and medium, architecture is the fundamental metaphor from which violence is derived, and as concrete body, the medium by which the postures of such forms are repeated, and by their repetition they arrange and position the "force of law." It concretizes located authority, it stages the projective imaginaries of resistance, exception, and resistance to exception, and so it authorizes location.

Resistance, Exception, and Exception to Resistance

An attack on architecture might be understood as an ulterior force acting within a given field of intensities that would otherwise place bodies and forms in suspension. But if it is an amplification of a set of relations always already in play, then how can the violence truly be exceptional in any conclusive way? Its means are never pure. An attack might be the project of another, competing, constituent force previously unknown to this field of forces, or at least not previously holding them in power, an act of architecture in the name of another law, placing one law onto the site by erasing the body of the other. But even so, this is not a simple power struggle of opposed constitutions scouring cities for bodies to haunt. If such media produce opposition as much as

they are produced by them, then architecture contributes specifically to the forces that claim it and are claimed by it, that refuse it and are refused by it. Architecture is not only the law itself (what Bataille called "the physiology of the social"); its substance is animated and suspended (like the law itself) by a violence that enforces the register of the law, as well as the means and medium of the exception to these, and the means by which exceptionality is itself conjured by prophecy, by ruse, or by both, into the territory.

Even when an attack on architecture is clearly an attack by a correspondent constituent power on a direct manifestation of the constituted power, and a negation of the law that would install itself in that place, it is not an introduction of violence into the architectural body. The attack may instead be an activation of the architectural body, in that the opposition between one and the other is fabricated by the partition, real or imagined. As one power is usually entirely complicit, not only in the creation of its opposed figure but also in the construction of the field in which they in fact oppose each other, exceptionality is itself dissimulation. What may have seemed like specific relationships between terrorism and architecture turn out to be more generally instructive, whereas specific conditions have been, quite dangerously, promoted to a generic strategy of the ubiquitous battle sphere.

A few years' distance from 9/11, the War on Terror and the concept of terrorism have been so generalized as to account for an undefinably vast and vague condition for a set of behaviors or outcomes, and with this the differentiation of the general and the specific relationship between terrorism and architecture is not only complicated by this diffusion, it is made pervasive. What then of Genet's

characters: the Police Chief, the Judge, the Priest? In pursuit of the general and the specific, the characters (besides those in and from the Brothel) are set into a corresponding configuration. Architecture in theory and in practice has been forced to re-account for itself according to the incisions it makes into the conditions of global society; architectural surfaces continue to come under attack as the material media of some intolerable social power. The registered object of that possibility, the first spatial medium—one's physical body—is weaponized and counter-weaponized, getting ever closer to the metal, while architecture proper continues its tuition as a first line of offense in the production of what Donald Rumsfeld used to compulsively refer to as "the security environment." As the brothel becomes a camp, and as the brothel becomes an enclave, the physical mediation of secondary material is formed by the incorporations and disassemblies of the architectural. The productive mimesis of one into the other may not be law, or need a law— even a law suspended or projected—but the law of force bears each an equivalent sovereignty from the other. For either an inside out (camp) or an outside in (enclave), the architectural partition provides the necessary function of the limit. That limit provides an architectural program by regulating the full possibility of flux and flow into regular formation, and in the codification of that regulation, the limit is that which gives anatomy to space by enveloping it, and that which produces eventful transgressions in its own image (stadium, skyscraper, school, shrine, slaughterhouse). At least in this way, architecture is, as others have said, intrinsically violent to the bodies and events that it witnesses because it is given intrinsic form by the social violences that scar territory into space by repeating themselves along the

way. Its work is less the exception to violence than the suspension of violence through historical time and by the mediating body of the built environment. The attack activates and extends the suspension and keeps it going. As that doubled violence is present in its own counter-formations, it is finally the Priest, more than the Judge, who champions the transgression that would bring a fuller flowering of the designable violent event, which is not actually exceptional to or excessive of the norms of everyday space but rather is their alibi and coconspirator.

The Law of the Door

Architecture (archaeo) is an "originary form." Any "first architecture" (a tomb, a shelter, a crypt, a bridge, or a bunker) is then the originary form of the originary form, not only of architecture per se but of society understood in its image. In this, architecture's primacy is supposed to settle matters by getting to their base. It is supposed to provide referential solidity in an uncertain circuit of association. It is both metaphorically and literally foundational. But if that foundation is itself a sort of shadowplay, rather than the way out of and away from the illusion, then architecture's primacy is primary to something rather different.

The Latin *potis* (from which comes the French *pouvoir*, including the power to see) refers to the master and mastery of the house. The word therefore inherently speaks to architecture, and around this term, Émile Benveniste long ago differentiated the seat of the host from the protocol of the guest, and had us grasp the nature of the home and its purview accordingly. There is no house without the one who claims it and there is no law, and no power in fact, without the house which it oversees. It is this claim regarding the reciprocity

and antagonisms of hospitality, and the identifications and identity that hospitality guarantees, that would wish to give character, by difficult extrusion, to the political enclosure of the nation versus its constant interpenetrations.

But when the table setting of the power over the house is as fantastic as it is edible, and when the image of a potential or prophetic law yet to come and a house yet to come can mobilize and legitimate greater violence than any present law, then what architecture is being worked toward? The sovereignty of the host, of the guest, of another law or another house that is always potentially to be built? Even as the solidity of the wall contains the violence of its formation (which is also its own exception), it is already a screen on which to project another house to take its place. As much as it sets host and guest across from each other, its concreteness gives surface for an imaginary alternative program. The real and its various ecstatic or mundane deferrals are equal masters of the house and its uncomfortable guests.

Posture with Bomb

Architectural typologies are variations on regime: they fix abstract and indiscrete definitions of corporeal space (what some would define as "religion") in immediate surfaces, volumes, and pathways. As said, violence cooperates with architecture in all matters of form, program, and instrumentality. It must. This is how and why it works. In formal architectural theory, the idea of "violence" has been rehearsed in several ways, some provocative and some trite. Peter Eisenman offered that "my work has always had a critical content and a formalism that resists. In that sense, I would argue that my projects are always concerned with

violence." A formal syntax is both dismembered and given a dominion over the affirmations of structure. Lebbeus Woods asked us to recognize the actuality of conflict in how architecture incorporates the damages of war in the wounded skins of the city. Gordon Matta-Clark directly cleaved the coherence of a building's body with slices and amputations. Likewise the operations of form and architectural program articulated Bernard Tschumi's disjunctive and unresolved tensions between event and image, positing the inevitability of violence and exploration of its agonistic limits. Architecture stands in for design as a whole, but that privilege is fleeting. It is challenged by both software and biology, but in the meantime it can do so by freezing habit into posture at the scale of a multiple urban body. As subjectivity emerges from the repetition and performance of particular roles, postures, and figures, it does so too from figures of historical violence. Peter Eisenman's entry into Herbert Muschamp's ill-fated *New York Times* competition for the then very recently cleared World Trade Center site features a series of towers "frozen in the moment of collapse." These striking, angular folds of glass and steel signified neither the architecture that was destroyed nor the "Spirit of America" the attacks purportedly targeted (and which Daniel Libeskind would eventually bargain himself into paying tribute) but instead the most direct and visceral eventness of the event: the incessantly repeated image of their structural implosion.

 This is the posture that is made into identity by repetition. In this most mediated of global events, the anatomical immolation of the anti-icon was mourned, consumed, habituated, and monumentalized as a compulsive rerun. A bent, painful contortion. Architecture became torn by a dual identification with the object of attack on 9/11 (Minoru

Yamasaki's towers) and, if the field is honest, with the extraordinary attention paid to the power of architectural symbolism after the attack as an essential and essentially expensive technology of public healing. The unprecedented interest in the public competitions to fill in the void with new architecture as significant as the violent anti-architecture that created it elevated the discipline in public esteem, and also perhaps irrevocably distorted its ambitions toward even larger gambits and dissimulations. As the current, permanent war on real and imagined enemies of real and imagined empires radicalizes its own predicaments, the convolutions seem to foreclose on ways out.

Polity and Composition

Terrorism is a form of designed exceptional violence. Its purpose goes beyond immediate "military" ends, and its impact is measured not by damage to the enemy's technical ability to respond, but by how far it rotates the political script in an intended direction and toward a particular narrative. Its hope is to recast terms of opposition within its own chosen drama into stronger relief. According to its own constitutional logic, but likely also according to the constitutional logic of the regime under attack, it is a violence undertaken as a measure that is exceptional to the authority of the attacked but normative for its own projective authority. It seeks to activate a historical shift by making the former give way to the latter: to substantiate another history by turning the exception into that norm.

In this light, contemporary terrorism may not resemble what Benjamin sought with "pure violence," but is rather a very specifically articulated (at least on its own terms) claim on the sovereignty to decide and delimit the exceptional state,

and to act upon that suspension with due means. Negation and insurrection are subservient and transient means; their claim from an elsewhere that would come to occupy the here and now is an interruption and eruption of one into the other. They assume without permission a specific right to legitimate violence, and also the historical agency to employ violence in the name of some other law and limit yet to come. In as much as the declaration of a state of exception also defines itself as a self-defensive measure taken by those who had no choice but to act, terrorism's own exceptional incursion is as much a revelation of a state of war that was already there as it was the instigation of new one. Terrorism does this by authorizing characters and their relative positions in its theater of cruelty. As a military strategy, it is unexpected (if not unexpectable) violence that seeks to localize and encapsulate a larger, intolerable conflict into dramatic miniature, setting protagonists in their mutual antagonisms and clarifying the plot for an otherwise distracted audience.

Terrorism's effect is affect: emotions of horror, fear, courage, solidarity, nihilism, indifference, boredom, cheap gestures of false conviction, and more. If Benjamin's "pure violence" is a recurring and irreducible act of spontaneous destiny, then terrorism is the genre-inflected simulation of that spontaneity and that destiny. Whether cynically or with full sentimental splendor, it composes—designs—the conflicted plot as an architecture that enrolls the unwilling in its program. By doubling emergencies in a proclamation of its offended norms, the law itself is redoubled by the simulation of state violence, which becomes itself a panorama of bloody set pieces. The moment that terrorism accepts the role of "the law" within this complicit

shadow play it assumes more weight than it can possibly carry for long.

The twentieth century was striated by explicitly political forms of terror. Not until 1979 or so (by Foucault's Iran, Bin Laden's Afghanistan, Falwell's New South, etc.) does a new religious terrorism really take the lead. Foucault was right about the turning-pointness of this moment, if also wrong in his valorization of Khomeinism. By the 1990s a clear majority of acts and fatalities was articulated according to theological motivations (mixed with political and post-secular vocabulary), signaling a fundamental shift in the architectural imaginary through which and over which wars are fought. For religious terrorists, violence may be sacramental, leaving the act unconstrained by the real terms and conditions of symbolic coherency. It may seek to attack not-carefully construed symbols (such as Aldo Moro as the Red Brigades's trophy) but more diffuse swaths of the Enemy (where the political theologies of Sayyid Qutb and Carl Schmitt may stand in for one another). Whereas symbolism of political terrorism is a function of limits on the vocabulary and protocols of the political as such, religious terrorism may see itself as outside not just the content of the polity, but even outside the jurisdiction of the political as a font of authority. This goes some way to explain how and why contemporary politico-religious violence is so conservative: atavistic, restorationist, irredentist, recidivist.

Religiously motivated terrorist violence is both a function of the secular globalization it acts against and a supposedly alternate format of governance (of bodies—especially women's bodies—of public spaces, of transactional economies). Architecture sees too much of itself in the utopian ambition of such violences; in how they

work according to fantastic projections of alternative landscapes, however progressive or regressive. This newer form (concurrent with the neoliberal era) depends also on haphazard tactical dedifferentiations of the secular from the sacred (and of the cosmopolitan and the fundamentalist), even when its stated goals include a restoration of their distinction. Whether it is Richard Land (the American Evangelical Christian security advisor to the Department of Homeland Security) placing *Heimat* in the hands of a disappointed Jesus, or Abu Bashir, the Bali Bomber, publishing his bestseller autobiography to an eager Indonesian public, the global terrorism/counterterrorism platform works by focusing religious energies onto otherwise secular matters. Just as terrorism blurs civilian and military spaces, the right to determine the relative profanation (more than sacralization) and the rendering of alternative global spaces becomes the precondition for violent visitations and the (pretentious, paranoid) architectural diagram of their juxtapositions.

First-Person Shooter

This shift in plot—from political theology to theological politics—does and does not follow a shift in the subjectivity and agency of the he or she or it who personally commits acts of exceptional violence. Some act anonymously on behalf of contested geography, and their lives and deaths are mere details in the career of a messianic redemption of the true community. In others the real charge is claiming a speaking position through the very act of spatialized violence. The content is secondary to the gesture's form. Linking the two is a popular (or populist) aestheticization of the "terrorist" as hero or antihero, menace or martyr. The basic reference texts for the interested researcher include an

unusual manifesto from 1884 by John Most, entitled "The Case for Dynamite," Leila Khaled's diary entry describing her overwhelming national pride viewing Palestine from the cockpit window of the El Al airliner she had just commandeered, and Red Army Faction's "On the Concept of the Urban Guerrilla," describing in purple grandiloquence the unique qualities of the contemporary terrorist. By second-order symbolism, Santiago Sierra's installation/attack upon the Belgian Museum Dhondt-Dhaenens bends the modern terrorist into the postural presumptions of the artist and his or her validating museum. And so on.

Terrorism's career has been closely tied to its own mediated representation, whatever the media and whatever the representation. From the hijacking events staged for the early years of live television to the global screen trauma of 9/11, to the webcast beheading videos from Iraq and Syria, the basic requirement of impacting a disinterested audience is the provision of imagery for consumption. Terrorism and the image of terrorism, as well as the terrorist and the image of the terrorist, are collaborative. The designability of exceptional violence is contingent upon a secondary narration of the initial image and its impression, or what we might today call its "optics." Damian Hirst goes so far as to say that 9/11 forever changed visual art and aesthetics, especially of the city, but 1970s celebrities (Carlos the Jackal, Leila Khaled, Patty Hearst, Ulrike Meinhof) and their portraits have become so iconic that they are finally inseparable from their deeds. As brands they come to signal the aspirations of those deeds or what the deeds represent, especially since the deeds can represent anything the consumer wants them to mean. The aesthetics of the "terrorist" are solidified by iconic repetition and

made available for Pop appropriation (Atelier Van Lieshout, The Clash, The Invisible Committee, the Hamburglar) and also for appropriation by groups self-identified as freedom fighters (see the Basque agents in their made-for-TV pronouncement, wearing ski masks with hand-painted, scary, scowling eye slits alongside the rote genre formalism of each beheading web video). Repetition means legibility, and legibility helps with the distracted audience problem. The agent becomes a character, which becomes an image of the terrorist, which becomes a position, and back again to the start. In the novel *Mao II*, Don DeLillo laments that the terrorist has hijacked the novelist's role as instigator of impossible thoughts. Joseph Beuys dedicated a documenta to Andreas Baader and Ulrike Meinhof on the run, tipping his (felt) cap to them, one superstar to another. A show about the RAF, "Zur Vostellung des Terrors: Die RAF," opened in Berlin before moving on to Graz, where it included many new works, such as photos by Doug Aitken showing hot girls wearing terrorist masks that were sold on eBay to help raise money for the ongoing staging of the exhibition. Bret Easton Ellis's supermodel terrorists from *Glamorama* became too boring too fast to even remember to include them in this list of examples.

In Gerhard Richter's "October 18, 1977" series of paintings of RAF members, the movement from event to mediation, as refracted in deliberate and comic mimicry, rotates the agent of exceptional violence from the cynical to the sublime. Or is it the the other way around? In these works, the half-remembered images of Meinhof, Gudrun Ensslin, Holger Meins, and Baader himself, dead in his cell at Stammheim, are rendered in exquisitely vague and noncommittal grays. The viewer is forgiven for not recalling the historical context quite

accurately; the mortal court of black-and-white ethics is blurred into incompletely recognizable forms, granting a limited reprieve to the figures and to their deeds. The terrorist violence in question is understood by Richter as already an image-of-violence, one that is itself already an object in and of the world that he might describe to us. That description has not only the phenomenal depth of the crumbling newspaper image, but contains the convoluted humanity within the aspiration, and the insanity, and the desperate agency of the convoluted rationales and contradictory implications of characters plotting a partitioned German history of partitioned Germany. By oneself or by the capable hand of another person, the designability of exceptional violence is conditionally dependent upon the design of its agent and her persona, an identity that is based less on the self-possession of exceptional sovereign anti-heroes than on the droll, ambiguous, symptomatic response by the audience: an image of an image of agency, rendered consumable so as to defer its purpose to any other melodrama you like, to another real or imagined emergency and another appropriation. This is not its illegitimate dilution; this is what it actually is and does. In this way as well, the terrorist and the architect share credentials, both showing up with plans for a new space, both jabbering on too much about the future of what goes where, both arguing with fantastic images, both at home in the demiurgic violence of zero-sum geography.

Violence and Projection

Architecture is (for better and worse) a highly privileged subgenre of science fiction. It makes propositions about the potential convergences of societies, protagonists, machines, and materials

and sets them in some seductive motion toward assemblage. Where science-fiction literature or film relies on the sentence and the shot sequence to effect this seduction, architecture enrolls its audience by drawing and model making, by program and perspective (or today rather .jpg, .avi, .aep). But architecture, as a visual cavalcade of virtual futures, is able to sustain popular interest according to what it does not draw: the invested scenarios of wish fulfillment that could be (if only) played out upon its stage. Entourage provides scale and mood, but the quality of personal events contained within a project's potential is left to each viewer to fill in according to one's own purposes. Wish fills it up and makes connections between things that have none: a Kuleshov space of public and private designs on thrones. In this, architecture's purported intellectual and discursive autonomy is a crucial (irreducible) special effect. Its representational authority—an "argumentative disinterestedness"—allows architecture to work as a generalized fulcrum for rendering the preferred evolution of political aesthetics itself. In Freudian theory, "projection" would refer to a defense mechanism whereby forbidden thoughts and impulses are attributed or transferred to another person or thing rather than to one's own self. The channeling of anxiety displaces some fantasy originating from within, relocating it onto the surface of something else, linking the impetus for that wish onto that surface as well. It is an identification process moving from the inside to the outside by self-servingly confusing one for the other.

 Cinema traffics in another kind of projection. The dark space of the theater scrambles experiences of inside and outside (of the room, of the story, of one's own body) and so becomes a surrogate of both the mental space and the phenomenal world.

Successful viewership must include a forgetting of the world and a prostheticization of sight and thought into the projection apparatus in order that the temporal flux of the cinematic image can provide a degree of immersion. The act of projection within the context of the cinema—aside from the actual apparatus—is one in which the viewer identifies with a character within the film and comes to an experience of one's own thought through the form and fate of that character. The motivations of the character become one's own. Here, then, the direction of Freudian transference is in essence reversed. Instead of projecting the wish from oneself onto the surface of another, here the character transfers his or her motivation and values onto the viewers. Seeing the face of the character with whom one is identifying there on the screen, in the camera/projector apparatus's objective elsewhere, above, or below, this time the arc of confusion moves from the outside to the inside. This cinematic identification, this inverse projection, is also then an observation of oneself in the third-person, future-perfect voice and tense.

Besides the fact that political violence is enacted on the projective screen of the built environment, and the fact that attacked regimes build defensive measures at urban scale, we also see that the iconic character of the terrorist (an agent who might startle the future into existence, from there to here) is at home with architecture's own utopian and messianic vernaculars, suggesting non-coincidental kinships between these visionary schemes. The terrorist shocking the future into emergence, the act of ritual violence itself, works by a revelation of the terms of the present, and, as for any ritual, its enactment establishes the identities of participants according to the purposes of its script. In this, the ritual is as much a diagram

of what must appear, as it is a rendering of inherited myth. This is the gamble of all conservatism: in diagramming the sequences of convergence and transubstantiation, it also allocates significance to the positions put in play. When serving as a technique of conservative religious and political programs, terrorist violence also acts according to this same ritual economy. The designed choice of targets, of media and means, of timing, of display, of purpose and outcome, creates a ritual scene in which people and places are arranged according to idiosyncratic, symbolic significances and interrelationships of which they are probably unaware. But, as already said, according to the vision of the design, this scenario hopes to be a revelation of the critical terms of a larger conflict.

Like the Javanese shadow play (*Wayang Kulit*) or the Catholic Eucharist, this scenario offers a mimetic miniature of the intolerable present state of history, in which this politician may come to stand for the State, this American for the American Empire, this Apache helicopter repairman for the larger occupying forces. Within the site of ritualized violence, the larger vista between agents of good and evil is reduced to a bare algebraic equation. This equals that, this stands in for that. Be done with it. The act of carrying it out for real is already a repetition of something else that may not even really be there, but because it believes itself to bring the critical terms of history into its simplifying mimicry, then the ritual sacrifice of the enrolled characters is sold as a transubstantiation of bodies and buildings by some prophetic resolution of the intolerable as first demonstrated in the plot's diagram. First the terms of the revelation are staged in miniature (this is us and this is you, a past and present) and then these are projected into an immediate future

repetition. The technique has a common track with all messianic teleologies, both secular and religious: the imminence of immanence. The preordination of history in eschatology or dialectical materialism or what-have-you demands such sacrificial vanguardist projections to keep them going, first as image and then by ritual deeds, organizing and ripping the present into a future that is inevitable according to a doctrine that needs bloody scapegoats and citadels.

The revealed diagram of the present (the plot) also shows the terms of future (if you stick around to see it go boom) fulfilling the projective wishful identification. In the mundane, everyday restacking of bricks on top of one another, the architect's diagrams are also a means by which the proposed future is given agency in the present, and according to which the present is able to structure itself accordingly, as another repetition in advance of itself. This exception may be rather ordinary, but at the same time there are always several futures going on at once. Just wait: there is a futures market. That is, Benjaminian "pure violence" is an ephemeral agency-of-agencies, and its purity is assured by the perpetual deferral of its arrival into an equally pure future. Both forms are named in advance and remain infinitely exceptional from everyday worlds, even as their doctrinal inevitability gives metahistorical significance to everyday worlds. What, then, is unexpected about an eruption of supposedly exceptional violence? Is the unexpected future only what arrives without having been already represented and demonstrated in advance of itself? Then terrorism is not exceptional, neither as a mode of attack or as norm making. What would be the power of these representations-in-advance-of-themselves to conscript anticipation into their eventual image? What do the apparatuses of

projection on which the emergency is screened (all of them) actually disclose or foreclose? Anything?

Dissimulation of the Double

"In being seen in conjunction with the original, the double destroys the pure singularity of the first. Through duplication, it opens the original to the effect of difference, of deferral, of one-thing-after-another. … In being seen in conjunction with the original, the double destroys the pure singularity of the first. Through duplication, it opens the original to the effect of difference, of deferral, of one-thing-after-another." Rosalind Krauss so compares doubling in surrealist photography with the notion of reduplication in linguistics that attributes signification to the reduplication of a sound, no mere babble, in that it suggests an intent of the speaker. "Repetition is thus the indicator that the … sounds … have been rendered deliberate, intentional, and that what they intend is meaning." Dissimulation tricks the truth more than it conceals it, like knowing inconvenient information you wish you didn't. Its techniques: camouflage (blend into the background), disguise (contort the model), and dazzle (obfuscate the model). See also: glittering generalities about propaganda. Example: camouflage as a form of visual deception, as an essential part of modern military tactics. Disguise: an appearance giving the impression of somebody or something else; for a well-known person this is also called incognito. Example: to depict a war as a peace mission as a war. Dazzle: distraction by phenomenon within the article, or manipulation of the medium. Example: the defensive mechanisms by which the octopus ejects thick blackish ink in a large cloud to aid in escaping from predators. See also: drag.

Such trickery is not only not aberrant, it is essential to the organization of all stable governing systems. Identification takes shape in relation to the potential viewpoint from the outside. Instead of being an external interference in the qualification of authenticity, it is central to the formation of the mimetic species (of which humans are the key exemplar). Sympathetic mimesis gives primary motion to the encapsulation of the body in an optical landscape only because the image of self is a continuous, bordered form, as seen in the reflection reflecting partition. The structure that tricks the organism into the manifest image of individuation is a reflective image that is also architecturally embedded. It reproduces a synthetic third-person gaze, a determining force in the mimetic strategies of flora and fauna, which allows projection in, projection out, and projection upon with equal promiscuity. In essence, even that structure is already dissimulation, as architecture endures its career as a metaphor for bodily form, as a prosthetic lifeworld or self-image, as a foundational referent for structure per se, as an original solid from which derivations might be developed. But such pretensions are held on its behalf. There are not commitments. As an allegory for corporeal structure, architecture is like the insect. It is a moth with eyes on its wings, a conjugation of materials and operations that participates in a landscape of optical projections. Architecture (as assemblage, as domus, as polis, as res publica) is the projective diagram of partitioned materials and images of materials, set just so within an agonistic array of postures and rates of decay. Architecture appears to be the place where the ludic flow of reversal and pantomime comes to rest in solid rings, but this is, like the grasshopper that gets cut, a paper-thin screen on which other ratios

are projected before being taken care of by usual suspects, interested parties, diverse stakeholders, trusted informants, and inarticulate contestants. We are all euphemisms, poking and clawing at ourselves in the reflective surfaces. We certify and credential these and insert this mis-recognition back into the architecture, optimizing it for better contrast and saturation. In turn, architecture's equally imbecile notions of autonomy are projected back onto us unsubstantiated. You can blame the design at your own risk.

Soft Target, Hard Target

Security design—form, program, system—simulates the veneer of an open-field normalcy even as it turns the environment into a deliberate instrument of force and counterforce. It shows force when none is there, and shows no force when force is actually there. Depersonalization by assimilation into space, the hostage is caught up in a lure of spatial identification and assumes an alienating identity, which will mark, with its rigid structure, the subject's entire mental development. It has begun to take the detour of photographic technology that will increasingly recode the surface of the urban environment and its range of vision. Trying to blend in, afraid of going to pieces, he already shut down the messages that his own body would routinely alert him to: fear motivates rigidity of performance; mimicry tends toward a becoming-inanimate. "A sort of instinct of renunciation that orients it toward a mode of reduced existence, which in the end would no longer know either consciousness or feeling."

The relative rigidity of what? A soft target is one that is unarmored or otherwise unprotected. A soft target could be an automobile or a house,

while a hard target could be a battle tank or a well-defended installation. A soft target can be overcome from any direction with typical ordnance used by regular line units, while a hard target may necessitate attack from a specific direction, with particular planning, en masse, by special units or a weapon made for the purpose. Hardening a soft target can be achieved by an addition of armor or use of additional construction, camouflage, mobility, co-location with defenses or another defended location, a human shield, or by placing it in a sensitive location like a well-populated city. And so just as terrorism is based on illusion and prophecy, so too is the architecture designed to counteract it. What is this power other than that conjured by messianic programs and security planning of cities in their counterimage? The most literal-minded distinctions of geography from architecture are set according to a ratio of density and firmness. Armored and exceptionally defended sites would be hard, while open, denuded structures are soft to the world of attack. What differentiates a hard from a soft target is not only the relative substance of the architecture's membranes, its concrete postures, but also how closely the program of the site is understood to be to the center of the terms of conflict.

In a culture war, there are no clear distinctions between military and civilian spaces or soldiers and civilian bodies, only gradient degrees of potential significance and implication. Any given form—a tall building, a night club, a train station, a refugee camp, a soccer stadium—could be a site of an attack or fortification against attack, or even some counterviolence. What is or is not a likely target depends on the semantics of the conflict(s). Vanguardist prophecies step into that opposition, however incredulously or sympathetically, so as

to retrain the architectural membranes and urban interfaces from however those fixtures realize their initial intentions. By inversion, the hostage is made their agent. To properly harden the architecture and to fortify it against other violences means to first anticipate in advance how it might be used by exceptional agendas and to steel against that potential metamorphosis. This is to internalize the terrorist's projection into already constituted spaces by those employed to police their security, by first remaking them in the image of the former's prophecy—whatever the latter imagines it to be— so as to prevent its fulfillment.

The panoptic surveillance of such spaces is, for example, also a viewership from the vicarious perspective of the terrorist who would create mayhem. It is to see what the enemy sees, so as to prevent the enemy's desire from being actualized there. In doing so the generic policing viewer must not only internalize that enemy projection but, in a way that projects fears into and onto the virtual terrorist to come, also amplify his own forbidden thoughts. Both projections are at work at once: architecture internalizes and substantiates the constituted projection and so makes it real, while the policing viewer must, by duty, project his own fears into what he imagines himself to see. One learns to love seeing the world through the other's eyes, ultimately requiring the other as a cipher through which to continue this state of galloping codependency. All security programming, all measures taken to secure the city, are recalibrations taken from the virtual image of that enemy, who would render his weird, indecipherable future into this present. "Why do they hate us? How do they see the same thing so differently, and what among all this is vulnerable to their desirous scheme?" By this classical projection

mechanism, whereby one's own forbidden thoughts are placed onto and attributed to someone else, one is given full legal reign to formulate space by an officially sanctioned paranoia, measured in the relative hardness by which various sites might fix their skins. But the pantomime of virtual perspectives, oscillating between offense and defense, constituent and constituted, can go both ways. Both sides can be in on the joke. Shock and awe, for example, and its Rapid Dominance doctrine, seeks to destroy an adversary's will to fight through spectacular displays of booming power. These displays, unlike regular first strikes, are a show of force for its own sake and for the audience's sake. They are less a type of instrumental violence than a spectacular image of violence as such, and a posturing threat of more to come. But it is a ruse. "The Iraqis" knew that shock and awe was coming. They were not surprised and dumbfounded by the scale of might on display; they were in on the gimmick just like all the other viewers.

Scabs

Another architectural syntax for becoming-debris might slash more directly into the quagmire of the militarized urban condition, and work like a recipe for turning the House inside out so as to build it from the wounds opened by war. It would be a syntax of scarring laid bare, of a direct truth for the self-destructiveness of social intercourse, and of the possibility of renewal, quite explicitly, in what Lebbeus Woods called the "scab." The design program does not aim to pacify these violences by monolithic memorialization. "Wherever buildings are broken by the explosion of bombs or artillery shells, by fire, or by structural collapse, their form must be respected as an integrity, embodying a history that must not be denied. In their damaged

states they suggest new forms of thought and comprehension, and suggest itself to be whole and free outside of any predetermined, totalizing system." Contained in these twists are layers of the grotesque, which become eventually apparatuses of beauty: plans, scenarios, and possibilities not only for new architecture but for new space, both with and without a new war.

"The new structures contain free spaces, the forms of which do not invite occupation with the old paraphernalia of living, the old ways of living and thinking. They are, in fact, difficult to occupy and require inventiveness in everyday living in order to become habitable. They are not predesigned, predetermined, predictable, and predictive. They assert no control over the thought and behavior of people by conforming to typologies and coercive programs of use, to preestablished ideologies and their plans to predominate in human activities under the name of an enforced unity of meaning and material. Rather they offer in the present, a means for living experimentally." Woods prosecutes any architecture which would exclude violence—real violence—from the reality of thought and practice. "Architecture," he writes, "the very model of precision and self-exalting intelligence, should not fear its union with what has been the lowest form of human manifestation, the ugly evidence of violence. Architecture must learn to transform the violence, even as violence knows how to transform the architecture." For architectural history, the "transformation of architecture by violence"—by war, by decay, by court-ordered implosion, by arson—is a far less detailed narrative than that of the production of official form by legal architectural signature. There are textbooks to be written about how architecture is subtracted; on the production of voids countless

perfect acts of anti-architecture. They are all no less instructive.

Building after Rebuilding: The Return, the Binding, the Repetition

More likely, architecture will be asked to entomb and sacralize secular violences. Reluctantly one site may be asked to register an itinerary of grieving, importing melancholia into mourning, internalizing a moralized aggression into monument and memorial. If the love for the lost—a love which cannot be given up, even as the object lost is given up—takes refuge in narcissistic identification, it becomes, for the city as whole, a self-tormenting melancholia that is no doubt enjoyable. It turns love into sadism and hate—first a hatred for what is lost, that is then turned upon the city itself. But the repetition of mourning is already a return of the repetition that gave rise to the event itself as architectural plots posit a model event in advance of its realization, a virtual strategy of turning systematic fictions into forms, and it shares this faculty with the plots of terrorist violence. (As said, each may be invested in specific solutions for an alternative territory, or the erasure of some ordinating politico-ontological geography to clear way for another. First they advocate possible futures, and second they mobilize technologies at hand for their realization, and in this their methods have repetition at the core. Both architecture and terrorism are first plots before they are actions; they are first projections before they are operations, and their agency on the world realizes itself in the repetition of this ideal.) The passage between architecture and exceptional violence is also in the accounting that the former is asked to do for the latter through symbolic monuments that fix and memorialize the trauma and its

public significance. Here the chain of repetition is one that moves from the event of violence to the political vocation of public architecture that formalizes collective memory.

Preparation for repetition is already in the formation of the script of religiosity: a binding repeated, a repetition bound. Further, in this remediation, only witnesses can finally credentialize the ensuing forms and events. This constitution of binding repeated, of iterations of assembly that produce sacred organizations in situ, underwrites architecture's role in providing a figural (even totemic) response, remembrance, rejoinder, or reinterpretation of exceptional violence. The work of mourning is a labor of repetition, and like all works of repetition, it produces characters, first by gathering and binding the world and then the audience itself. In the monument, architecture's work of mourning is asked to repeat the trauma of the exceptional violence and to render that event in the physical language of public sculpture. This vocation for architecture reassembles the extant debris of the world, perhaps even the debris created by the violence itself, and rebinds it into another singular form at which and into which the mourning's repetition can be invested. It represents and renames the violence by repeating it and reversing the effects of its violent designs. In this rebinding and in this drama of mourning, worldly materials (stone, wood, metal) become significant beyond themselves. Whether this marks the violence on the actual place of its occurrence or marks a proximity to some other officious center, like a capital, a particular sculptural constitution of materials inaugurates this one site as the medium for some imperfect history and memory.

The work of the monument is also the gathering/binding of the collective in its spectatorship

of this remembrance. The political function of the monument's commission is the memory of exceptional violence according to client-government's narrative. As the architectural concretization of a language of memory forces a site to organize repeated gatherings around a repetition of the violence, the spectating public itself is also enrolled to trace this economy of symbolic refraction. The language of monumentality hopes to coordinate for the crowd a pluralized ideal; it is just as much a vocabulary for targeting attacks on built forms that carry significant currency, as it is a way to give form to the memory and mourning of an attack. But what alternatives are there? Some echo across interests. Jean-Luc Godard's *Notre Musique* repeats Woods's characterization of war as author: by scarring, war resculpts the city, tearing into the skin of its surfaces, and so the proper memorialization is to leave such scabs in place. Instead of disinfecting the city and then installing a secondary sculptural memorial in which to condense mourning and memory at some later date, both would allow the wound to remain and to focus the history on its own future, that is, the city itself. Some forms can do both. Peter Eisenman's Holocaust Memorial in Berlin, a relentlessly mute field of abstract figures, echoes Primo Levi's gray zone in which a holocaust would annihilate not only the premise of rationality but also of a history predicated upon its alibis. It cannot be spoken of other than through the remainder of a barely articulated presence; like the impossibility of witnessing the inside from the out, a mediation on the impossibility of understanding the annihilation that the genocides set in motion. Eisenman's grove of stones marks a terminus point of something irreducible and incomprehensible on the site of its genesis. It is a final

obstacle drawn in the middle of the city that was the epicenter of a violence (that cannot be) represented and so cannot be mourned away.

Erasure Produces a Currency of Form

Architecture's place in this economy of memory and monumentalization is not just to absorb or recall the energy of the attack; the violence of the attack can also make architecture that was once insignificant to everyone but the terrorists and their idiosyncratic imaginary into something monumental. For example, McVeigh's attack on the Murrah building in Oklahoma City turned an anonymous government tower into a critically fractured obelisk, in which national discourses of core, periphery, and federalism were invested. Monumentalization was primary in the violence, not secondary as it would be in the memorialization of an already significant building. Where before there was only building, now there is a sacred site, a center, a "heartland" fabricated from the discursive ether. Almost immediately after the attack, the improvised tributes began with hundreds of wreaths and bouquets laid onto the most jagged parts of the rubble, as if to soothe them. These initial rituals on the newly sacred site would hope to perform a suturing of the fissure, not just in the building's body but in the integrity of American civil society that the bomb punctured. An official monument would later be built that literally restaged the sequence of events as a pedantic diorama for anyone unclear as to what went on, but more importantly, Murrah memorialization is not those mawkish rows of chairs and frozen time but rather the television image of the building ripped open and disemboweled, now a charged martyr's body into which the social energies of memory and remembrance can be invested, over and over.

Consider Mohammed Atta, the pilot of the plane that hit the northern Trade Center tower and one of the ringleaders of the plot, who also studied architectural engineering at Cairo University and then urban planning at the Hamburg Technical University. His masters thesis on Aleppo, Syria, was concerned with the conflict between western modernization and traditional Islamic values. For Atta this conflict was simultaneously spiritual, moral, and an urban planning problematic. While his thesis does not advocate a violent, radical solution, it is impossible not to relate the attack on the World Trade Center to his framing of the problem of the city in terms of a global spiritual conflict, and global spiritual conflict as materialized in the built city form.

Atta hated the ways in which the architectural and urban modernism of the West was destroying the aesthetic and spatial logic of the Islamic city. In 1995, he left his planning job in Hamburg to make a pilgrimage to Mecca and to travel to Cairo to observe the restoration of two military gates, Bab al-Nasr and Bab al-Futuh. In his essay, "Money, Sex, God: The Erotic Logics of Religious Nationalism," Roger Friedland writes that

> these military gates are charged with symbolic importance. Bab al-Nasr means Gate of Victory, associated with one of the names for God, al-Nasr, the all-victorious. Bab al-Futuh means the "Gate of Liberation." Al-futuh, which literally means an "opening" or a "bringing into light," refers to the liberation of non-Muslim lands and is particularly applied, for example, to the conquest of Crusader Jerusalem. These military gates signify Islam's conquering powers. ... Unusually made of stone, rather than brick, they were built between 1087 and 1092 by the Fatimid

vizier of Acre, Badr al-Jamali, who had been charged by the Fatimid caliph with putting down a revolt by Turkish rebels. The two gates not only define an outer perimeter of the Islamic medieval city of Cairo but enclose Fatimid Cairo, a space identified with the territorial unity of the Islamic world in that the Fatimid caliphate claimed universal authority over all Muslims and—in political theory, at least—unified sovereign and religious authority in that office. They also stand for Islam's pan-ethnic reach, in that both the caliph who ordered them built and the vizier who built them were Armenians, not Arabs. ... Atta was outraged by the way in which the Egyptians were restoring them. These gates, charged with Islamic significance, were being made into an Arab Disneyland for Western tourists, at the same time that the poor Islamic neighborhoods around them were being razed and the Muslim Brotherhood clinics and daycare centers were being suppressed. It was after Atta returned from Cairo to Hamburg that he moved into an apartment with two other suspected hijackers. During the ensuing years, he both trained in the al-Qaeda camp and finished his thesis—with high honors—on the defense of the Islamic city from Western modernism. If you look at the Cairene gates whose restoration so upset Atta, they have an uncanny similarity to the target whose destruction he masterminded. When Atta flew the civilian jet into the north tower of the World Trade Center, it was an anti-architecture, destroying one twin tower to defend another.

Porosity, Partitions, and Paroxysms
When architecture is in a defensive posture, its preventative design is a pre-monumentalization

of sorts; it is a mimesis-in-advance of violence, originating from the constituted law, and now an active collaborator of the attack plot that would disassemble it. At the scale of the nation, the border partition is the limit at which point interiority delineates the state's jurisdiction, and the possibility of a geographically articulated sovereignty. That partition is held in a perpetual suspension by challenges to that constituted limit and by its own intrinsic reversibility. On the border, the checkpoint thickens the line into a liminal space of indeterminate duration. This first-encountered epidermal layer of the state generalizes the internalization and externalization of population flows into and out of its survey. It is at the fixed outer core-membrane that cleaving work of the partition and the operations of enclosure become the same task, and so too this is where they coordinate as technologies of political formation and deformation. In that coordination, the intrinsic reversibility of the border membrane cannot help but reveal itself: the bunker that becomes a camp is the camp that becomes a bunker, one a prophylactic and one a quarantine, and each exchanged for the other under armed supervision. Please stand behind the yellow line. No wonder then that airports are such a critical theater for staging and channeling the reticulated economies of sovereignty, terrorism, and counterterrorism. They are always liminal zones by legal profile where borderlines are extruded with occupiable architectural thickness: hijacking, security checks, shoe removal, holding pens, holding pens for others, X-rays, boarding passes.

 As such, the War on Terror is also a war on behalf of any politics that would instantiate itself by this liminality. It is, in this way, a war on liminality fought with enforced liminality. It is, in short a

space for a the crowd always shifting direction, a vast metabolic tumult from which this one sort of sovereignty would draw representational legitimacy. And yet it does this, as we see, by acts of fantastic and delirious prostheticization. It refers always to other partitions in its revenge against and on behalf of the walls, and takes for granted the image of the population-as-horde that figures prominently in some but not in all anti-modernities, from the work of Elias Canetti and Gustave Le Bon to contemporary military theory of the feral city, and any governance that preoccupies itself with curtailing and contouring this volatility. For this project, the city is first a system for cleaving the crowd from itself and modulating what gets in and out of the overall sphere of influence.

For example, consider the Los Angeles riots of 1992 as another extreme expression of collective architectural practice, one bent on a particular type of inversion, seeking the reversal and return of the city as given. People were also hurt, to be sure, but the most focused surface of rage against the system was an attack on buildings themselves. Angelenos took to the streets and attacked the immediate embodiment of delegitimized power and its physical architecture: the composition of instrumental signifiers, signs, boundaries, transit zones, everyday commodities, glass windows and iron bars that together form a general urban economy of retention, resentment, loss, and displacement. That architecture which contained the system, concretized it, embodied it, and enforced it was smashed, set aflame, and eradicated. After the verdict, the physical concrete city—literally the concrete—was possessed by that spirit of false consensus and its now too-outrageous impositions. As the social is manifest in the physical form of things, it is to

the physical form that the mobilization of counter-enforcement would turn. To attack the counterfeit public is to attack its host—destroy the messenger, burn the medium, turn it inside out, invert it around the axis—and a new pattern is written onto the urban surface. Put differently, the Rodney King verdict itself was a unilateral suspension of the Angeleno social contract and an act of succession on the part of certain white suburbs and their cherished mythologies. For those who participated in the counterviolence, however strategic or misguided, the interface of that breach was made available—or so it was thought—in the architecture of most proximate authority: an available city-form overstuffed with the pretensions of public and private governance now poisoned with tendencies of injustice. To access that now-redacted social contract and return its notice of its unacknowledged suspension, the skins of the world were actively stripped of their differential values and turned back to debris. Negating the negation, the city itself was sacrificed.

Still, despite all that, the thickness of the border and the range of the crowd are always bound by contiguous cartographic denotations, and some can be nonlocal even to themselves but no less architectonic for it. By projection and prosthesis, their multiplication can challenge the center from its own remote interior. Put another way, just as architecture may code the forms and deformations of the social, it may itself be unwound by the residue of other forces, courses, and affects. When Le Corbusier writes, "it is the question of building which lies at the root of the social unrest today: architecture or revolution?" he asks, is architecture to solidify the same modernity, or is to clear the field and make way? Even that opposition would eventually

collapse, and re-situate architecture as another sort of agent and field of history, and so redefine revolution itself as a drive toward spatial recomposition and an organization of forms against and through them. But architecture is not just becoming-to-form; it is always already the not-yet-debris. As it is cast for corporeal and incorporeal habitation, architecture is a stage on which these activations give and are given duration, and one on which those same activations are negated. It gives centers, marks time and countenance, and engraves states as landscapes, all so that someday negations of the same can dream of erasure, or worse.

Salo, West Virginia

In the Manichean pantomimes of war, viewing publics are cast as "witnesses" and into an unaccountable (and uncompensated) cognitive labor of their affective reaction. On the city-size display of the Abu Ghraib torture party images at a demonstration at Trafalgar Square, Ananya Vajpeyi wrote: "It is not clear to me why it's alright [sic] to put photographs of torture in loops and play them like music videos at a concert in the open air with thousands of viewers, even if it is a gathering of protest. Displaying the human rights violations and crimes against humanity of Abu Ghraib in a public setting without giving viewers a discretionary option—to me this seems like a gross misuse of the media. It is an assault on the viewer and also disrespectful to the victims whose misery is turned into a global spectacle. War crimes must have witnesses for there to be justice, but an antiwar demonstration is not a space for acts of witnessing that have any standing or use in a court of law. As participants in the demonstration, we were all forcibly turned into spectators of both the cruelty of the perpetrators

and the suffering of their victims, the debasement of the American soldiers at Abu Ghraib and the humiliation of the Iraqi prisoners. If my act of witnessing cannot serve a legal purpose or a political purpose or even a moral purpose, I do not want to be arm-twisted into this kind of spectatorship. Images of torture are not entertaining, not instructive, not informative, and not valid instruments of propaganda that purports to be non-violent in its methods, its medium and its message." But that is not their point—to be entertaining, or instructive, or informative, or valid instruments of propaganda that purports to be nonviolent in its methods. Their point, in this context, is to put you to work. They need you more than you need them, and it is, by the way, precisely the point of a demonstration to turn people forcibly into spectators. For the Command, Control, Communication (C3) apparatuses the space of war and its own oppositions is an actionable interface for administration at a distance. It is derived, by one lineage, from the Napoleonic battlefield tower, the optical logistics of Norbert Wiener and Claude Shannon's missile cybernetics, the camouflage techniques of the false bunker and the invisible soldier, and Wilhelm Reich's experimental camera systems and the cults that sprouted up around them in Pasadena. C3 is a carnivorous envelope of disclosure, and its core axiom is to see the enemy in advance of the enemy seeing you, and so this apparatus composites cities into cinemas and scopophiliac and scopophobic interfaces into an amalgamated conspiracy of forensic publics.

CBS's *60 Minutes* first broke the story to the global viewing audience on April 28, 2004. From a prison complex formerly utilized by Saddam Hussein's forces to administer torture on suspected dissidents—some place called "Abu Ghirab"—we

learned that between October and December 2003, American prison guards had not only routinely tortured Iraqi prisoners in a sadistic frenzy of homoerotic scatophilic Grand Guignol, but that they had taken dozens and dozens of images and videos of their exploits, and had even choreographed their danse macabres for the purpose of staging these images. Many of the guards were only too eager to share their dramaturgical accomplishments and, as is the nature of the digital image, hundreds of duplicate copies circulated by e-mail beyond the control of the military investigation that had been initiated in January of 2004 by Lieutenant General Ricardo Sanchez. The Chairman of the Joint Chiefs of Staff, General Richard Myers, requested that CBS delay running the story, which they did for two weeks, but once the lid was off, the summer was overflowing with more and more images that seemed evidentiary of something primary to the whole conflict. President Bush was quick to distance the military from both the images and the motivation for their production, even going so far as to speak directly to the Arabic-speaking media about the matter. Mainstream media outlets were conflicted about how to even show the images, if at all, and equally how they could justify not showing them, considering their cutting testimony about the war as a whole and the mindset that executes it as such. If we are the troops, did supporting the troops mean disclosure or discretion?

 In the following months attention would focus on the troubled psyches of the apparent ringleaders of this S&M geopolitics, the end-of-the-world lovers Private First Class Lynndie England and Specialist Charles Graner. Formal juridical blame didn't stick to the skin of a system that gives responsibility to these pick-nose characters, and would conclude, for

the record, that these aberrant knuckleheads are in no way representative of, agents of, connected to, or instruments of the larger Coalition civilization. Nope, not a bit. Stigmatized and thrown to the wind, England sits in the brig waiting to have Graner's baby; an unfortunate person it will be to have been conceived in the wake of this weirdly drawn-out foreplay. The official disavowal of these images from the war as a whole was unsuccessful, because the images themselves took charge of that whole. A new iconography for Operation Whatever-It-Is had been excreted upon the global war audience, who would come to interpret it for its own purposes: as an interface between the Coalition and Iraq, between the West and Islam, as a teachable moment about sexual humiliation, bodily profanation, animalistic degradation, and bare-knuckles brinkmanship.

No Civilians on Earth

Less than a year later, the arrival of streaming beheadings further darkened the last days of the second Iraq War. For this terrorist projection, civilians and combatants and all the in-betweens were over-coded and over-enrolled as extras in a savage transvestism of incommunication, as hand-puppets ne plus ultra mutilation of the enemy. Neck in hand, the corporeal form is exploded open for the horrified audience, not just as a body but as the actual body of the enemy, reduced to this rubble of inert flesh. As the coalition incursion in Fallujah unfolded, reports began appearing of the discovery of the "slaughterhouse(s)" where "several" of the beheadings videos were shot. It is still unclear whether one or more "houses" were found and exactly what was found there, who in fact was killed where, and so forth. Major General Abdul Qadar Mohan, chief military spokesman for the

joint US-Iraqi operation, indicated that they "found hostage slaughterhouse(s)" (some reports indicate this in the singular, others in the plural). He says that they also found hundreds of CDs containing names and records, black clothes like those worn in the videos in "the northern portion of the city," which could mean anywhere north of Highway 10, including near the Muhammudia Mosque, purportedly used as a command center. Considering the attention on three of the western hostages then still missing (Margaret Hassan, Christian Chesnot, and Georges Malbrunot) it is surprising that no one has mentioned yet if there was record of them having been there. When asked, the general said, "I did not look closely." Perhaps they were being tight-lipped about what was known. They did claim, however, to have looked closely enough to reverify all sorts of complicated foreign backing of the insurgency, as if the coalition were there mainly to keep non-Iraqis from determining the country's future. For what it is worth, the former hostage, Mohammed Raad, a Lebanese truck driver who was kidnapped and forced to watch the decapitation of another hostage, an Egyptian (Mohammed Mutawalli) then later set free, tells of how on the sixth day of his being held, "he was taken away by a second group of kidnappers, who claimed to be members of the Islamic Movement of the Holy Warriors in Iraq—the Saif al-Islam brigade. After eight days of captivity, he was driven to a remote cluster of windowless single-room mud huts deep in the desert not far from the border with Jordan" (quoted in the *Lebanese Daily Star*, October 15, 2004). This group claims affiliation with Abu Musab al-Zarqawi (as do many). Raad's testimony would put at least some of the filmed locations hundreds of miles west of Fallujah.

"I'm an American out of the United States. I work on an Apache helicopter." So says Paul Johnson, beheaded civilian, in his pre-execution statement. "Civil space" is eaten alive by both terrorism and antiterrorism, and each works to enroll viewers—willingly and unwillingly—into their conspiracies. For both, civilians are already participants in a larger dramatic apparatus that contextualizes their daily lives' significance to sacred battles taking place without their knowledge or interest. A helicopter repairman is kidnapped and beheaded in Saudi Arabia, busloads and trainloads of western urbanites are blown apart, Hummer dealerships are burned to the ground: from "we support the troops" to "we are the troops." At least four conversions of the modern constitutional partition of the civilian and the military are at work here: Civilian bodies are recast as agents in the conflict (Paul Johnson et al.). Civilian spaces are recast as agents in the projected conflict (Bali Nightclub). Military bodies recast as civilian bodies in exile (We Are the Troops). Military spaces recast as civilian spaces in exile (Camp Liberty in the Green Zone). The world, as a whole, and as a whole of parts, becomes an interface of war somewhere else, because the whole war becomes an interface of the world somewhere else. There are no civilians on Earth because the whole world is a soft target.

Let's unpack the cadaver of this Paul Johnson, the roly-poly contractor helicopter mechanic living in Saudi Arabia who found himself on the wrong side of the knife. First, are al-Qaeda in the Arabian Peninsula, his dispatchers, civilian or military? Do these terms clarify nothing about the organization or its aims? Instead, in the extra-legality of it all, the beheadings are at least as much a demonstration of civilian versus civilian as military versus military.

The violence is maximum and constitutional, but the apparatus of a military ritual is secondary, if necessary at all. So what currency did Johnson's cranium offer as trophy? Perhaps the most succinct answer comes from a video-game cheat site. Referring to the game SimCopter, the site presents: "Perhaps the ultimate cheat, only available in cities with military bases, is the Apache helicopter. Fly to the military base, land, get out of your helicopter, and get into the Apache gunship loaded with machine guns and missile launchers." Johnson's specialty as a contractor prosthetic of the military was to repair damaged night-vision systems. Itself a prosthesis of the flying pilot warrior, a night vision system motorizes the heat-seeing capacity of a flying gunship into a human sensory and cognitive apparatus, and in the form of bullets, coming back again. Bodies all entangled, technically and programmatically. "I work on an Apache helicopter." Not all of them, but some of them, more than one. A helicopter that was used for a particular act of aggression or defense. Not necessarily this Apache helicopter, but an Apache helicopter. Not necessarily these targets, but targets like them. Not necessarily this American, but an American like him. Not necessarily this building, but a building like it. The grammar of this condensation is both miniaturization and linear transference; it is an associative, categorical argument, both like and unlike the way this particular ritual sacrifice might be planned, staged, and presented. It must be just so, but it could also be any of them.

Where Snuff Comes From

Since the end of "major combat," more than 150 foreign nationals have been taken hostage in Iraq, and now dozens of repetitious videos of

captives being ritualistically decapitated with handheld knives are the grammatical synthesis of the opportunistic violence of this protracted conflict. With Paul Johnson's Apache right in the middle, the clarity of the videos' symbolism is both bone-chillingly direct and totally opaque and pointless. Their violence extends to their being viewed at all, and to the enrollment of global publics in what CENTCOM (United States Central Command) calls their "optics." As propaganda of the deed, the videos spin in every rhetorical direction at once, overwriting and overpowering argumentation as such. Yet what could be a more direct image than what they show, in their repetition and redundancy? They all look alike, they all sound alike, and they are all seemingly cut from the same autistic script. But their "technology" is in the casting of the lead, that poor, no-longer-anonymous, quasi-civilian functionary of the Coalition apparatus. In their global viewership, the videos enroll and implicate their star victim, not really as a sacrificial soldier, but as an everyday civilian tool of an occupation force that has already smeared the boundaries between professional and military occupation well off the map. The videos are not aimed at the enlisted US soldiers. They are aimed (precise, redundant lines of sight that they are) on the viewer himself, the one who still rationalizes his life and work to be that of a civilian back home in the larger scheme of things.

An incomplete list of the videos would begin (before the invasion of Iraq) with Daniel Pearl, a journalist working for the *Wall Street Journal*, killed in Karachi, Pakistan. During the period of the Iraqi occupation, the video roster would include, in no special order, the executions of three unidentified members of the Kurdish Democratic Party; Ramadan Elbu, a Turkish "truck driver who

transports supplies to the American forces"; twelve Nepali contractors; Shiite Iraqi Ala al-Malik, accused of spying for US forces; and Fabrizio Quattrocchi, an Italian security guard guarding oil pipelines. They were all killed by the Ansar al-Sunnah Army. Our Paul Johnson, a night-vision systems repairman of Apache helicopters, was killed by "al-Qaeda in the Arabian Peninsula," purportedly lead by Abdul Aziz al-Muqrin, who was gunned down shortly after the images of Johnson's death were made public. Luqman Hussein, a Kurdish translator accused of participating with US forces in raids in Ramadi, who was working in Iraq on behalf of the Titan Corporation of San Diego, California, specializing in C4ISR (Command, Control, Communications, Computers, Intelligence, Surveillance and Reconnaissance) services to the Pentagon, along with Maher Kemal, a Turkish contractor who reportedly worked with the Americans at a base north of Baghdad; Barie Dawood Ibrahim, an Iraqi contractor who worked on air conditioning and telecommunications projects for US and Iraqi forces; Anwar Wali, an Italian of Iraqi origin and an unidentified Turk; Fadhel Ibrahim and Firas Imeil, Iraqi National Intelligence officers, killed by the Brigades of Abu Bakr Al-Sidiq (affiliated with al-Zarqawi's Tawhid and Jihad); Kim Sun-Il, a South Korean translator; Durmus Kumdereli, a Turkish truck driver who shuttled supplies to the Americans; the independent American telecommunications equipment worker Nicholas Berg; eleven as-yet unnamed Iraqi policemen and National Guardsmen; Kenneth Bigley, British contract-engineer, who was seen in two videos pleading for his life; and separate videos threatening and then carrying out the threat to decapitate American civil engineers Jack Hensley and Eugene Armstrong, all killed by Abu

Musab al-Zarqawi's Tawhid and Jihad group. The month of October 2004 was by far the bloodiest, with the Ansar al-Sunnah Army focusing its efforts on non-western exemplars, playing to a different global audience than al-Zarqawi's Tawhid and Jihad, who continue to menace the imaginations of white Westerners in particular.

A differentiation of these videos from "snuff" films would hinge on the lack of any overt or likely sexual thematics. One side of the argument holds that a snuff movie is footage of an eroticized murder, and the other says that any murder, staged, framed, narrativized for the purpose of it being filmed suits the definition. Whatever value this appellation may hold in this case, we would today use "snuff" to refer to a film that actually exists, but this was not always the case. The term "snuff movie" dates back to 1972 in Ed Sanders's book *The Family*, his behind-the-scenes account of Charles Manson's followers and their lives leading up to, during, and just following the murders they did in Hollywood, for which they became infamous. According to the prosecution, these murders and the painting of coded messages on the walls in victims' blood were intended to pin the blame on "Black Revolutionaries" and to incite a reaction of fear and revulsion in the white middle class so extreme that it would lead to the instigation of a full-scale race war culminating in the end of civilization. In the book, Sanders interviews a peripheral family member and questions him about rumors that the Family had made use of Super 8 cameras they had stolen from an NBC news truck in the months before the murders to film their activities, including a "short movie depicting a female victim dead on a beach." In the described scene the girl's body is decapitated.

Meanwhile, it was Dick Gregory who first showed the footage shot by Abraham Zapruder of President John F. Kennedy's 1963 assassination to the public on a television show hosted by Geraldo Rivera in 1975, called *Good Night America*. While still images had previously been published in *LIFE* magazine, it was more than a decade after the assassination that the now-permanent image of the president's moment of death would be made public. Further afield, the cinematic destruction of the body has been employed for tremendous artistic effect over and over again. Stan Brakhage's *The Act of Seeing with One's Own Eyes* (1971) uses autopsy footage to construct, slowly but irrevocably, a myth about the very possibilities of form and legibility, ethics and time. Alain Resnais's *Providence* (1976) begins by showing a body in the act of dying and the dissembling fate that awaits it in autopsy. Earlier, Georges Franju's *The Blood of the Beasts* (1949) documented Parisian slaughterhouses; it is one of the landmark films of the century. Also perhaps before its time, Michael Powell's *Peeping Tom*, released in 1962, the same year as *Psycho*, examines the cinematic/physical violence and the compulsion to document fear and pain. Martin Scorsese sponsored its rerelease in 1979. Back and forth it goes. Given this history of snuff, it is not too surprising that the first of the beheading videos from Iraq that most people saw, that of Nicholas Berg's, was presumed by some to be a hoax. Maybe it was part of a more sinister cinematic conspiracy perpetrated by the CIA to divert attention from Abu Ghraib where the image machine had gotten out of hand. Though what is more innocent and more disturbing is how the frozen, redundant dramatic structure of the beheading videos has become a script understandable even by children.

We Are the Troops

The doubled but certainly not interchangeable atrocities of beheading videos and the Abu Ghraib torture games .jpgs turn degraded, profaned, dehumanized bodies into sacrificial symbols, and for this they are proximate shuttles for the suicide bomber's transformation of his or her own person into a preemptive instrument of spatial warfare. The weaponized civilian body here inserts itself into soft targets and toward a grotesquely ultimate "deterritorialization," reversing its solidarity with the mass medium of the biological crowd. The suicide bomber scrambles contracts and mutilates programs premised on duration and daily continuance, if not actually permanence. The act, however deranged, however devoted or faithless it may be, demonstrates (to itself and to us) a refusal to "go on" as a particular character cast by an enemy program of habitation (national, religious, linguistic, "ethnic") manifested under the cover of anonymity. He walks onto "a bus," into "a café," into "a crowd." Not every bus, café, or crowd—but at least one. That given site (designed and designated, composed and constituted) elaborates a specific formal incorporation and will do for now. It is, as one place among other places, a component in a larger contest of geographies, and the pedestrian's performance of this repetition wears into that place and reshapes it accordingly—place becomes habitat for predator and prey. To re-perform, consciously or unconsciously, a role demanded by any place's script is to accept a requisite inscription as the legitimate position for one's own person. With or without a bomb strapped to it, the meandering body is the transport of an ongoing architectonic conflict that is fundamental to political participation. As first-person munition, the suicide bomber refuses that

casting, and in lieu of the necessary political technologies with which to counter-inscribe a site, he or she attacks the same medium through which the offending geography works: bodily habitation itself.

In the midst of the act of suicide his body triggers a self-extinguishing and then self-amplifying feedback loop—refusing, reflecting, and returning the ordained identification of location, wiping it of programmability, and possibly also claiming it thereby for another nation and narration in a place now cleared of the offending plots. Another less-direct violence of the suicide bomber is the suspension of the premise of habitation per se, its patterned repetition toward collective formal location. The immediate anatomical violence at the site of the explosion also instills fear in those who would otherwise blithely occupy those same places in full confidence of their everyday roles. The fabric blanketing habit, habitat, and habitation is torn. Facing the new everyday program of the randomly exploding pedestrian, the city struggles to maintain the illusion of normalcy. The battle is surely over real space, but also over the perception of space. This part of the war is phenomenological, as victims of suicide attack are those who have lost the lottery of thereness. One group struggles to focus their benign existential illusion, drowning out the din, and the other to blast that inertness to bits, each a soldier-civilian in the other's plot.

Meanwhile, the inverse conversion of the military into a remote civilian space is realized by the simulated American Mall within the Green Zone, known as Camp Liberty. Here architecture is a pharmaceutical device helping to enforce a mandatory sense of normalcy; it would sooth the minds of the troops and helps shift the zone of exception back into the normative. From camp to bunker

and back again: a bunker is the zone of normative order within the space of emergency, and here in the mall it is made hyper-regular, decorated with the dull interfaces of consumer life, re-plugging the soldiers back into their psychologically civilian lives in the defended elsewhere. In the same vein, the Hummer's grotesque hypertrophic design language outflanks We Support the Troops with I Am the Troops. This conclusion is shared by the International Hummers Owners Group (IHOG), who say the car and its ownership is a way to materially extend a patriotically defensive posture into the homeland, as well as by the Earth Liberation Front, who burned all the Hummers at a dealership near San Diego. Back and forth we ramble with righteous hesitancy.

Franchised Accidents and Airport Dramas

Planes are better than horse-drawn carriages in that plane crashes are better than horse-drawn carriage crashes, except for those involved. While the power of a technological system to organize the world in its own image may increase, its inability to prevent its own inevitable breakdown remains constant and irreducible. But the abdication of agency regarding an event as dramatic as a plane crash, shifted now from human pilot to random systemic fissure, is a hard pill for many to swallow and, for some, even insulting to the economic dignity of humanity. For example, when the space shuttle Challenger exploded on liftoff in 1986, the specter of sabotage was everywhere. The pride of American engineering and the national self-image of a country used to looking toward NASA for events around which to produce a patriotic center was on the line. When the Feynman panel investigating the

incident concluded that the culprit was a defective rubber ring, attention turned to finding "the person" who was responsible for the breakdown in procedure and an oversight that could have allowed this to happen. But as Diane Vaughn's comprehensive study demonstrates, the organization of incremental decisions, debated criteria, and weighed options that preoccupied NASA and Morton-Thiokol, the manufacturer of the ill-fated O-Ring, was carried out properly. According to available science they did it all correctly, and made all the right choices, one by one. There was no signatory of calamity. The difficult conclusion is that the shuttle exploded even though the system of checks and balances operated exactly as it was designed, not because of any deviation. Likewise, when TWA Flight 800 exploded soon after takeoff from New York in 1996, the presumption of terrorist mayhem was nearly a consensus. The official word, however, was that it just happened by accident. The official word is that sometimes, for reasons beyond our control or comprehension, airplanes sometimes blow up and fall out of the sky, which must surely be true. Rather than cowardice and incompetence, this is an admission of bracing honesty and implication.

Al-Qaeda is, some say, one image of the architecture studio of the near future, or perhaps is already the design studio and science-fiction collaborative of the near present. Recall its plot to put biological agents in the handprints of Marilyn Monroe at Mann's Chinese Theater in Hollywood, so that thousands of tourists, who can't help but put their own naked hands into the famous prints, would become infected and then board hundreds of airplanes back to hundreds of homelands. The *New York Times* tells us that "terrorism can be viewed as a warped mirror image of the new economy. In that

financial structure, corporate chieftains manage lean, trimmed-down firms, bringing in consultants and freelancers to perform specific jobs. The specialists work as a team to complete an assignment, then move on to other jobs, often for other companies." Some are model, decentralized, just-in-time organizations of multinational freelancers, run from the top by the son of a civil engineer who can claim, as much as anyone, to have literally built Saudi Arabia.

Likewise, the airport is asked to play the central stage for public space, a request underlined by the securitarian reaction to 9/11. Concurrent with the oil crisis in the mid-1970s, airports were reconstructed to conform to defense imperatives against hijacking. Buildings were built according to traditional technical constraints, but were designed to minimize the risk of contamination, and terminals were planned to discriminate between a sterile zone (departures) and a non-sterile zone (arrivals). All circuits and circuit breaks (i.e., passengers, baggage, and freight) were submitted to a discriminatory (interior versus exterior) transit system. And so, as the state's first and last gateway in and out, the airport became, like the fort, the harbor, or train station of the past, the home of crowd-centric regulation. One passenger-civilian gains access to the city no longer through a gate, an arch of triumph, but rather through an electronic audience system whose users are not so much inhabitants or privileged residents as they are interlocutors in permanent transit. More recently it has matured into a more perfect field for intensive testing, control, and observation. Unlike the monotony of the hijacker's sitcom, Stanley Kubrick in *2001: A Space Odyssey* cast the very future of the species in a metaphysical layover. Chris Marker's vision of the end of the world begins

and ends on *La Jetée* at Orly, next to a magazine stand and pretzel cart, which just goes to show.

In the postcolonial implosion of peripheries into the core, the airport and sometimes the individual jet plane were restaged as zones of destiny. Seldom are commercial jets actually procured as the artillery of an opposition air force, but the architecture of the drama is not always one of straight possession. Sometimes the plane becomes a bunker, sometimes a stage set, sometimes a missile, and sometimes it is made into a sort of living ruin of a civilization in disrepair. To provoke enemy responses to spring into reaction according to the script may itself be the desired effect. But the airport is special. It is not the temple, not the bank, not the church, not the public plaza; the airport becomes the local embassy of global authority, and so the host for direct violent challenges to it. If the cabin space is a miniaturization of the airport, which is itself a miniaturization of the city, which is itself a miniaturization of the World System, to commandeer the cabin space, to hijack it is to purloin a concentrated version of that totality for one's own temporary ends. Instead of capturing the obelisk, the hijacker takes the scale model. Yet by now it's not certain, even for true-believer terrorists, that the totality even exists, and so to capture its token doesn't really fly. The aggregate body of interfaces undergoes not just a crisis of representation but of reproduction, because if it is not challenged by irregular exception it cannot repeat itself. That is, state security is now not only invested in the deflection of alien hostiles, but in defending the fragile contiguity of its own social form, watching itself metastasize into generic fundamentalism and its attendant dissimulations. That is its point, if it even has one.

End: The Security Environment

The narrator now shambles onstage with all the rest and takes his place in the lineup. Over his head he wears the bad rubber Donald Rumsfeld mask, around his neck the rubber ball gag, his gray sports coat tied around his waist and some sort of electrical cord trailing around his ankles. The Judge waves his arm, motioning the narrator toward the stage front and into the spotlit column. Clearing his throat, he pulls out a wad of papers, which he unfolds. "We are in a new national security environment," he says, "one that requires careful attention to information warfare, missile defense, terrorism, defense of our space assets, and the proliferation of weapons of mass destruction throughout the world" (12/28/00). He taps his foot hard on the stage as if to dislodge something stuck. "Weakness invites and entices people to do things they would otherwise avoid. Our task is to fashion deterrence to fit this new national security environment" (01/26/01). He tries to bend over and take off his shoe but gets tangled in the electrical cord and almost falls. Irma, Carmen, the Torturer, and the Police Chief all jump to catch him, but he doesn't fall. "What was previously an abstract possibility became on September 11 an appalling reality, and our security environment must now be seen in a fundamentally different and considerably darker light" (12/19/01). He turns the paper upside down, then over again, looking for what he will read last, and then apparently finds it: "An ability to adapt will be critical in a world where surprise and uncertainty are the defining characteristics of the new security environment" (01/03/02).

With that, the Court Envoy approaches the narrator in the Rumsfeld mask and pulls the ball gag up and into his mouth. His head jerks. He turns to leave stage right but he hesitates, trying to say

something through the ball gag to somebody. No one responds. He makes another sound—a bit louder, but still unintelligible—and then leaves. Fears become beauty and their indigo dress becomes abstraction, applications of feminine masks without disguise, and we find ourselves back at the commonality of camouflage that conceals by mimicry the presence of a butterfly or a storage depot. Once more they all together intone that in mimicry it is supposed that the object imitates its surrounding environment, so as to fit in and hide itself from surrounding prey or potential attackers. Nature is assumed to be hiding something; mimicry is either an offensive or defensive strategy, for both predator and prey. The Chief of the Police, the Priest, the Judge, and Irma wait in line to pick up their boarding cards and check their luggage. They leave. A building, a server, a terminal, and a shipping port are all illuminated stage left as registrations of exchange and prophylactic postures. All the suitcases are full of franchise paraphernalia, masks, makeup, ammonia, hats, rubber gloves. One by one they disappear up the ramp and onto the carousel that will reunite them with all the other luggage. The stage lights dim, each one in sequence, until the House itself is left as the only occupant of the stage. Silence and stillness, and only the House with no host and only guests. It stays this way until the audience eventually decides that it's over and that they can leave.

"Of Simulation and Dissimulation"
by Francis Bacon (Published 1625)

Dissimulation is but a faint kind of policy, or wisdom; for it asketh a strong wit, and a strong heart, to know when to tell truth, and to do it. Therefore it is the weaker sort of politics, that are the great dissemblers.

Tacitus saith, "Livia sorted well with the arts of her husband, and dissimulation of her son"; attributing arts or policy to Augustus, and dissimulation to Tiberius. And again, when Mucianus encourageth Vespasian, to take arms against Vitellius, he saith, "We rise not against the piercing judgment of Augustus, nor the extreme caution or closeness of Tiberius." These properties, of arts or policy, and dissimulation or closeness, are indeed habits and faculties several, and to be distinguished. For if a man have that penetration of judgment, as he can discern what things are to be laid open, and what to be secreted, and what to be showed at half lights, and to whom and when (which indeed are arts of state, and arts of life, as Tacitus well calleth them), to him, a habit of dissimulation is a hinderance and a poorness. But if a man cannot obtain to that judgment, then it is left to him generally, to be close, and a dissembler. For where a man cannot choose, or vary in particulars, there it is good to take the safest, and wariest way, in general; like the going softly, by one that cannot well see. Certainly the ablest men that ever were, have had all an openness, and frankness, of dealing; and a name of certainty and veracity; but then they were like horses well managed; for they could tell passing well, when to stop or turn; and at such times, when they thought the case indeed required dissimulation, if then they used it, it came to pass that the former opinion, spread abroad, of their good faith and clearness of dealing, made them almost invisible.

There be three degrees of this hiding and veiling of a man's self. The first, closeness, reservation, and secrecy; when a man leaveth himself without observation, or without hold to be taken, what he is. The second, dissimulation, in the negative; when a man lets fall signs and arguments, that he is not, that he is. And the third, simulation, in the affirmative; when a man industriously and expressly feigns and pretends to be, that he is not.

For the first of these, secrecy; it is indeed the virtue of a confessor. And assuredly, the secret man heareth many confessions. For who will open himself, to a blab or a babbler? But if a man be thought secret, it inviteth discovery; as the more close air sucketh in the more open; and as in confession, the revealing is not for worldly use, but for the ease of a man's heart, so secret men come to the knowledge of many things in that kind; while men rather discharge their minds, than impart their minds. In few words, mysteries are due to secrecy. Besides (to say truth) nakedness is uncomely, as well in mind as body; and it addeth no small reverence, to men's manners and actions, if they be not altogether open. As for talkers and futile persons, they are commonly vain and credulous withal. For he that talketh what he knoweth, will also talk what he knoweth not. Therefore set it down, that an habit of secrecy, is both politic and moral. And in this part, it is good that a man's face give his tongue leave to speak. For the discovery of a man's self, by the tracts of his countenance, is a great weakness and betraying; by how much it is many times more marked, and believed, than a man's words.

For the second, which is dissimulation; it followeth many times upon secrecy, by a necessity; so that he that will be secret, must be a dissembler in some degree. For men are too cunning, to suffer a

man to keep an indifferent carriage between both, and to be secret, without swaying the balance on either side. They will so beset a man with questions, and draw him on, and pick it out of him, that, without an absurd silence, he must show an inclination one way; or if he do not, they will gather as much by his silence, as by his speech. As for equivocations, or oraculous speeches, they cannot hold out long. So that no man can be secret, except he give himself a little scope of dissimulation; which is, as it were, but the skirts or train of secrecy.

But for the third degree, which is simulation, and false profession; that I hold more culpable, and less politic; except it be in great and rare matters. And therefore a general custom of simulation (which is this last degree) is a vice, using either of a natural falseness or fearfulness, or of a mind that hath some main faults, which because a man must needs disguise, it maketh him practise simulation in other things, lest his hand should be out of use.

The great advantages of simulation and dissimulation are three. First, to lay asleep opposition, and to surprise. For where a man's intentions are published, it is an alarum, to call up all that are against them. The second is, to reserve to a man's self a fair retreat. For if a man engage himself by a manifest declaration, he must go through or take a fall. The third is, the better to discover the mind of another. For to him that opens himself, men will hardly show themselves adverse; but will fair let him go on, and turn their freedom of speech, to freedom of thought. And therefore it is a good shrewd proverb of the Spaniard, "Tell a lie and find a troth." As if there were no way of discovery, but by simulation. There be also three disadvantages, to set it even. The first, that simulation and dissimulation commonly carry with them a show of fearfulness, which

in any business, doth spoil the feathers, of round flying up to the mark. The second, that it puzzleth and perplexeth the conceits of many, that perhaps would otherwise cooperate with him; and makes a man walk almost alone, to his own ends. The third and greatest is, that it depriveth a man of one of the most principal instruments for action; which is trust and belief. The best composition and temperature, is to have openness in fame and opinion; secrecy in habit; dissimulation in seasonable use; and a power to feign, if there be no remedy.[1]

[1] Francis Bacon, "Of Simulation and Dissimulation," in *The Works of Lord Bacon: With an Introductory Essay, and a Portrait*, vol. 1 (London: Henry G. Bohn, 1871). First published 1625.

El Proceso (The Process)

i.

Xefirotarch makes vampire architecture. The reasons for this go beyond the now well-known series of incidents at the group's recent SFMOMA show, during which, over consecutive days in the spring of 2006, several children were left bleeding and traumatized by their encounters with the installation. Each claimed to have been "bitten" by its forms, but more likely the children had fallen upon one of its dangerous, fang-like angles, and left punctured by the sharp contours. One boy was hospitalized for nearly a week because of his injuries. The linear gash in his abdomen is now healing, but he remains adamant that the work lunged at him and not the other way around.

Hernan Diaz-Alonso was home in Argentina when the *San Francisco Chronicle* ran coverage of all this, and as I have co-taught several classes with Hernan at SCI-Arc (Southern California Institute of Architecture), the suspicious journalists seeking quotes eventually buzzed my phone instead of his. I patiently repeated that Hernan was not really in the architecture business in any normative sense, that his work was pursuing something else, and that, no, I was not really surprised by what had happened. The quote that ended up on the paper the following week had me suggesting that Xefirotarch was some combination of Victor Von Frankenstein, Alfred Hitchcock, and Raytheon. "What began for [Diaz-Alonso] as a pursuit of cinematic botanical monsters, became, in ways he himself does not necessarily control, profiles of allegorical cannibalism ... and probably even actual weapon systems." San Francisco's political culture being what it is, my remarks were positioned as ethical warnings or as criticisms, though I meant them as neither.

ii.

Philip Johnson visited the Greek island of Naxos in 1927 and was caught up in a local vampire panic spurred by a cholera outbreak. This visit and its predicament would change his life. Johnson's extensive travels during this period were greatly influenced by his Harvard studies of the pre-Socratics, particularly Zeno and Parmenides. Naxos is the island where, as mythology has it, Zeus himself was raised in a cave. For Johnson, this particular pilgrimage to Naxos's caves, to a primal architecture of sorts, was an important but unplanned addition in his itinerary. His diary notebooks from this period, now in the archives of the Getty Institute in Los Angeles, suggest that this trip through the Cyclades Islands was to last for no more than a few days. "I will be back in Athens before you know I was gone."

Shortly after his arrival, several locals fell ill with cholera. Though this disease is by no means uncommon in the area, its treatment, including isolation of the bodily fluids of those infected, was unsophisticated. Infection spread quickly across the island from its first point of outbreak in the village of Filoti, where Johnson was staying at the time. Johnson, probably unaware that having type O blood made him unusually susceptible to the bacterium, seemed to register the situation with more annoyance than fear. "They are dropping like flies, and it's even harder to find a decent guide or dinner for that matter," he writes. His guest (and perhaps host as well) in this trip was a mysterious Italian a few years his senior, Aldo Gelli. Little is known of him, other than that he was the older brother of Licio Gelli, head of the notorious Propaganda Due, a "black" Masonic lodge that operated out of Rome from the 1870s and throughout the turbulent years

of the 1970s. As we will see, P2's role in the history of vampire architecture would not be understood until years later, during the trials of the secret police involved in coordinating terrorist attacks on civilians that were blamed on the Red Brigades, the so-called *strategia della tensione* (strategy of tension).

The panicked population on Naxos, at the time no more than 6,000 in total, had their own explanation for the cholera epidemic: they laid blame on *vampires*. This did not bode well for Johnson and Gelli. In the Cyclades, vampires were thought to be indistinguishable from living, normal humans, and the correspondence between the odd American's arrival and the immediately ensuing deaths led many to deduce his direct responsibility for murder. In fact, such vampire/cholera hysteria would continue to recur on Naxos, the last recorded in 1959. Johnson's own diary accounts of the following days are written in an uncharacteristically alarmed prose, too fragmented to produce a clear picture of what happened and what exactly enabled his escape from Filoti. What is known is that Gelli had made arrangements for them to stay on the less-inhabited southern part of the island in a military compound of some sort, perhaps official, perhaps privately owned. Johnson would note several times the compound's proximity to Mount Zas and the cave of Zeus's youth, and he refers specifically to several furtive visits made to that site. Johnson did not reappear in Athens for a full month after his departure, but the exact date and route of return from Naxos remains unknown.

Of the many pages of loose text fragments that comprise his notes from these days in the compound while sheltered by Gelli, perhaps the most striking are several pages of fragmented commentary on Lord Byron's poem *The Giaour*. The title of this

work is from the Turkish word for "nonbeliever," and the poem itself was written mostly in 1810, during Byron's own sojourn through Greece and "the Orient," and in particular to Naxos. It concerns the fate of a westerner in Turkey who avenges the death of a slave girl who had loved him and so was cast into the sea by Hassan, her disapproving master. The poem was part of a collection of works by Byron published upon his return to England, all of which painted clashes between West and East, Christianity and Islam, the center and the periphery, in rhythmic Romantic prose. An excerpt from *The Giaour*:

> *But thou, false Infidel! shalt writhe*
> *Beneath avenging Monkir's scythe;*
> *And from its torment 'scape alone*
> *To wander round lost Eblis' throne;*
> *And fire unquench'd, unquenchable,*
> *Around, within, thy heart shall dwell;*
> *Nor ear can hear nor tongue can tell*
> *The tortures of that inward hell!*
> *Bur first, on earth as Vampire sent,*
> *Thy corse shall from its tomb be rent:*
> *Then ghastly haunt thy native place,*
> *And suck the blood of all thy race;*
> *There from thy daughter, sister, wife,*
> *At midnight drain the stream of life;*
> *Yet loathe the banquet which perforce*
> *Must feed thy livid living corse:*
> *Thy victims ere they yet expire*
> *Shall know the demon for their sire,*
> *As cursing thee, thou cursing them,*
> *Thy flowers are wither'd on the stem.*

Johnson makes several entries regarding Hassan's fate, that of becoming a vampire after death and doomed to prey on friend and foe alike. In fact

Byron's rendition of this Islamic Turk is sometimes said to represent modernity's first literary vampire.

There are also long passages in Johnson's diary, perhaps written after his escape from Naxos, considering the connection between his own predicament—locked away as an accused vampire—and the local vampire legends that must have inspired Byron and him to innovate with this poem after his travels a century earlier. Here again Johnson's notes become less orderly. He discusses the character of Lord Ruthven in the story *The Vampyre* by John Polidori, Byron's personal physician, repeating the commonly held assumption that this decadent, aristocratic variation on the vampire character must have been based on Byron himself. Johnson notes that the story was produced by Polidori as part of the same challenge that inspired Mary Shelley to construct *Frankenstein*, on a now-famous night at Byron's retreat on Lake Geneva. Johnson notes that the vampire and the Frankenstein monster are both figures of ritual cannibalism, and that "Frankenstein's electrified *mélange* of corpses—a figure of re-memberment if not also dismemberment who is revived from the grave—and *we*, the vampires, were born that evening like awful twins" (italics mine).

This is only one of many passages from his diaries in which Johnson referred to himself as a vampire. In others, even more explicit, he cites a "furtive volition of the vampire ethos" in the careers of several historical figures, from Piranesi to Henry Ford. "The power of the machine," he writes, "is its seduction, and the power of its seduction is in its secrecy, which is to say in its natural affinity to the necessary opacity of our positions. Vampires formulate order but do so by hiding in the open, like our work."

Put plainly, Johnson returned from Naxos believing that he had, quite in fact, become an *actual* vampire. How this should be understood in terms of his mandarin power brokering, and the patrilineality of architecture that became his legacy, is an open question.

iii.

I went on to explain to the reporter from *The Chronicle* that Hernan and I had both started teaching at SCI-Arc at the same time, and that when we first met we had talked about the impact of software on design epistemology, and about the movies, particularly the autonomous function of "special effects." We half-jokingly agreed that in "1993" software had replaced Theory as the most important means by which design thought through itself.

At that time, almost simultaneously, and certainly not just in architecture, software had emerged and Theory had gone away. We toyed with this, presuming impossibly linear causality. Years later, at the time of the SFMOMA exhibition I had just finished a short essay on our collaborations for an issue of *AD: Architectural Design*. The issue had to do with the pursuit of "elegance" in contemporary architectural design, and Xefirotarch's work was an obvious touchpoint for this. My problem in formulating the piece with the editors came down to a rather basic difference in agenda as to what the elegant *is* and *does* in Hernan's work, and for contemporary aesthetics in general. One might presume that elegance is a kind of graceful, synthetic exclusion of inelegant complications, such that what is left, what emerges through this exclusion—itself a seemingly effortless finesse— is a rarified, even innocent beauty forged through eugenic subtraction. However, in Hernan's work

(I mean the act of working more than the stuff that results) the revelation of elegance was the result of the reckless pursuit of its *opposites*. Whatever clarity and cleanliness that was there arrived, perhaps counterintuitively, through the direct exploration and amplification of the horrific and the grotesque on their own terms.

I tried, probably unsuccessfully, to explain to the *Chronicle* journalist that this comes from Hernan's interest (obsession really) with cinematic effect more than anything necessarily native to architecture. "It's not that he's influenced by film, it's that for him the act of designing is itself cinema. The forms you see are special effects minus the representational, photographic content of the camera." The reporter seemed to be trying very deliberately to not follow along. I read a direct excerpt from the *AD* piece, called "Mayan Cinema," hoping that might clarify.

Xefirotarch's design obsessions are based in an appreciation for the perversity of elegant form, a taste learned from the movies and set to work on architecture. That said, perhaps Xefirotarch's architecture is itself "elegant," and perhaps it is the inverse of elegant—horrific. Perhaps when the projected figure is frozen in a sufficiently dense, opulent articulation it does achieve a resonant state of elegance. But if so that achievement is derived as much from the act of designing that figure as it is from the intensity of the resulting form. It is produced in the act of design, less through special techniques or processes (though also through these) than in the focused sensations of pointing and clicking. Here that sensation is more like painting than engineering: driven by personal, idiosyncratic gesture more than an application of systematic procedure to material condition.

The genesis of this is internally driven but not intuitive. Having watched hours, weeks, months of Bad Hitchcockian cinema, microtechniques for combing the thresholds of the horrific-becoming-elegant and the elegant-becoming-horrorific have imprinted themselves as visual-temporal cues on the design retina. These codes (cut here, blend there, match-on-action, shot-reverse-shot, false POV, staccato violins, etc.) are processed, mashed up, and re-projected back onto the screen space of animation software. There image-forms are densely layered and then pulled back from themselves, balanced and unbalanced, such that their formal "architecture" within the frame always competes with the strictures of the edit—the latent seam— for the organization of the screen-event. In the course of such moments, he is director, editor, and audience all at once, watching the form materialize and interacting with that emergence. His decisions to speed up and slow down, slice and blend, fuse and separate, repetitions of scenic rhythms he has learned from a lifetime of being awed by cinematic folds and fissures.

Listening again to the recording of the interview, I hear myself pausing and coughing. I go on.

This is visceral. Like the filmgoer engrossed into the cinematic apparatus of yore, this well-immersed designer sweats and squirms and grunts over what he watches before him. This is an exacting processing behavior, like the subconscious mind during dream state, cycling through the raw data of everyday life's input, cutting and pasting, iterating toward multiple provisional renders on the mind's eye. The designer settles into the twilight consciousness of productive concentration, into an unfolding practice that is also kind of cinema played out on the camera obscuras of

his glowing monitors. Any elegance you read within the final render is an index of the precision of this processing.

"So it's like [inaudible]," the journalist asks.

"Perhaps, but from another time I think. Do you know the cockroach scene from Hitchcock's *Frenzy*?"

"No."

"*Frenzy* is one of his last films. It's about a mad strangler in London and his attempts to stay hidden. There is a key allegorical scene in the British version that was cut from most of the American edits in which a swarm of ants eats the severed finger of one of the victims. Hitchcock uses probably fifty cuts in this sequence that is no longer than fifteen seconds total in screen time. Some shots may be POV from the ants. Hard to say. At any rate, the accumulation of edits becomes an accumulation of perspectives around the action of the eating of the finger. This accumulation of perspectives works to trace and delineate what can only be described as a form or membrane *around* the event of the finger. Each cut notes a different point in the field that together, in the speed of the actual film sequence that somehow 'add up' to this visual shape."

"I see."

"Hernan and I discussed this sequence a lot. I believe that his own design decisions, his own acts of editing in Maya, are not unlike Hitchcock's. It is basically the filmic editing techniques of juxtaposition and acceleration and freezing that provide the conditions of emergence for the filmic formal architectures that we see on the screen. And then later simulated into the gigantic 3-D model in SFMOMA. The one that apparently bit that kid."

iv.

El Proceso de Reorganización Nacional, or "The Process of National Reorganization," usually known simply as El Proceso, was the official name of the authoritarian agenda of the military junta and its partners that ruled Argentina from 1975 to 1984. The Process took its inspiration from numerous sources, including historically similar adventures in military-corporatist purging and consolidations in Spain and Germany, of Stalinist regimes that were purportedly the junta's world-historical enemies, as well as junta leader Jorge Rafael Videla's own personal involvement with Robert de Grimston's Aleister Crowley-inspired cult group, which was also known simply as The Process. In the years 1969–70, Videla spent months studying with de Grimston in London, traveling back and forth at least eight times, and he credits this association with providing the regime with "a philosophy of will through which we will guide and witness the revitalization of the Argentine body and spirit." The reclusive de Grimston also visited Buenos Aires in the early years of the Argentine version of The Process. As in Santiago, tens of thousands of suspected Leftists were detained at football stadiums in and around Buenos Aires and kept in the stands at gunpoint as spectator-prisoners. Survivors have testified that de Grimston would address the assembly over the stadium's loudspeaker system with cryptic sermons about death, destiny, illumination, and other esoteric topics. In fact, two photographs taken inside the stadium in 1976, which were used in court testimony, show a figure now thought to be de Grimston surveying a lineup of prisoners.

Propaganda Due's involvement in El Proceso was, at least initially, through the AAA: a strangely elastic organization and acronym that would

at times stand for the Alianza Anticomunista Argentina and/or the Association Architecturale Argentina (Argentinian Anti-Communist Alliance and/or Argentinian Architectural Association). The AAA's origins as Isabel Peron's personal security forces preceded the junta, and it was during the years leading up to the beginning of El Proceso that many of the group's most violent adventures were realized. Among these were standing camps in the jungle where barbaric medical experiments were routinely performed and later institutionalized. After the junta took power, Rodolfo Almirón took control of the AAA and dramatically expanded its involvement from a tactical death squad to a full adjunct of other strategic security initiatives, eventually including planning a New Argentina. Also under Almirón's control, the AAA became an active platform for Propaganda Due's attempt to remotely influence the long-term future of Latin America as a whole (as well as in Italy). P2's ongoing research into an "architectural eugenics" and a "eugenic architecture" was beginning to bear fruit in Europe and its core participants were eager to test their conclusions beyond laboratories and studios, at the scale of a large population. They strategized that Videla's Argentina and El Proceso could provide that opportunity.

With Videla's enthusiastic blessing, P2 enrolled prominent members of Argentina's architectural community in a new AAA, which would provide cover for the original AAA. The outrageous medical experiments of the AAA were used as the basis of both a new Argentinian national body, as well as a new platform for its architecture, its cities, and its infrastructure. Ideas and techniques moved freely between the eugenic experiments in the jungle and the forms and plans in the designers'

studios. What might begin as child's severed appendage may end up as the formal basis of a new water treatment facility that would allow for the settling of an otherwise inaccessible terrain. Conversely, the profile of models for a new Federal satellite complex to be erected in the north would be abstracted into an indexical method for ranking the scars on the broken palms of captured students.

We now know that between 1977 and 1979, at least half a dozen international masterplan competitions were conducted in secret, and largely orchestrated by P2 on behalf of the ruling regime. Johnson was secretly enrolled to oversee the jury process for these, and it is from notes in his personal diaries that what is known of these competitions can be partially reconstructed. The entries ranged from the monolithic to the monstrous. One entry, perhaps that of Oscar Niemeyer's office (though it is impossible to know and there are many reasons to doubt Niemeyer's participation), called for the dissection of the entire western half of South America into a vast grid system of concrete avenues running across the continent. Spaced ten miles apart both north/south and east/west, each avenue would house necessary infrastructure such as plumbing and transportation, as well as an uncertain population of laborers. The squared landscapes in this gigantic grid would be left feral and lawless, allowing for, as we read in Johnson's notes, "a ferocious zone of maximal natural selection, from higher mammals such as the Indians to carnivorous plants and poisonous frogs." Another (again without assignment of signature) called for the relocation of the Vatican to the jungle in a New Rome, from which an ongoing project for the "fulfillment of the Christian vocation, design [of] new wombs, new bodies, convert[ing] the entire

Amazon into a bridge of bread and blood. Built with the genitals of pagans."

V.

News site clipping:

In March 2007, self-proclaimed vampire hunters broke into the tomb of Slobodan Milošević, former president of Serbia and Yugoslavia, and staked his body through the heart into the ground. Although the group involved claimed this act was to prevent Milošević from returning as a vampire, it is not known whether those involved actually believed this could happen, or if the crime was some kind of political theater.

The secret of the vampire, as Johnson intimated, is that there is no secret. It's all in your mind. You want to be controlled, and so the ritual assignment of the spell is all the news you need to respond to suggestions coming from within not from without. That suggestion is all the more real for its psychosomatic origins, and for the weight of the soldier's hammer on flesh. One of Hernan's professors, when himself a young student in Argentina, had his right hand smashed by the junta. He disappeared and returned, like a ghost, like a living dead. Once a brilliant draftsman before his instrument was destroyed, and still an adamant Communist of sorts, he instilled a different vision in his young student, turning him away from an interest in film toward an architecture of sorts.

Vampires have a complicated relationship to patrilineality. They bite, consume, and pass along the right to bite and consume. This is their asexual reproductive strategy. The occult telos of patrician cultural governance includes secret meetings atop the Seagram Building and dinners in the Glass House in New Canaan, where architecture's own

Skull and Bones met in the 1960s and '70s. Johnson did die, without heir apparent, and architecture's own menu as a particular private parlor of national new-old money went as well. That death was a function of a globalization that would open up the game of urban-scale formal symbolism to colorful Malay-Chinese plastics fortunes and Chelsea-Dubai oil futures in ways that cannot be controlled, or even supervised, from a permanently reserved table at the Four Seasons. As if they ever could.

After the Chromopolitical Revolutions of 2005

A future textbook on brand theory will recount for disbelieving readers an episode in political history during which several national reform movements, in the winter of 2005, became resolutely and romantically *chromatic*. For example, the supporters of Viktor Yushchenko in particular, and of electoral and political reform in general, bathed Kiev, and themselves, in Orange. Supporting the movement—one that was soon much more broadly inspired than its initial support for a single candidate—meant showing your true colors. And Orange was it. The telegenic success of this branded paroxysm inspired others to follow suit. Eastern Ukrainians opposing the Oranges wore, belatedly, an opposite hue of blue. In a span of several weeks, Lebanese critical of Syrian meddling initiated a cedar green revolution; Iranian secularists adopted pink; and, in a floral variation, there was a rose revolution of sorts in Georgia and a tulip revolution in Kyrgyzstan. Of course, purple-thumbed Iraqis were favorites for a few days as well. (Elsewhere, under this radar, truces between Bloods and Crips, red and blue neighborhoods, were crumbling, and former leaders of the Khmer Rouge were being slowly brought to trial.) By March, it all seemed a bit out of hand. Was some cabal of brand consultants flown in to assign different reform movements their particular shades? (Yes, as it turned out.) Did movement leaders decide on a color in advance of their mobilizations? (Yes.) What would happen if two ideologically opposed movements both claimed the same color? (Both anarchists and fascists have at times costumed themselves in black.) Would they join up, across borders and across contexts, or would they negotiate some kind of mutually beneficial licensing agreement? (Neither.) Would the political spectrum ever be the same? (Unknown.)

When these chromopolitical movements work well, as they did in Orange Ukraine, a color can enroll the broadest and vaguest possible platform of aspirations under a single voice and hue. Colors are a popular negation of all that is unliked and a welcoming affirmation of some ill-defined, preferred alternatives. The power of the chromatic movement is that a color means precisely nothing. To be activated, it requires the participant herself to fill in the all-important details with her own idiosyncratic aspirations. By comparison the process is more flexible than the articulated iconicity of a flag. A flag is a specifically colored sign that signifies some designable, conceptual "center" for a government to govern. But the contemporary chromopolis is more diffused and decentralized. A flag has a protocol of use, but in Kiev anything can be Orange, and so it is. The re-skinning of everyday life marks the advance of the Orange movement into civil, personal space, since its incipient, amorphous promise is everywhere and on everything. As a team-building exercise, it resembles preparations for some important football match, but this chromopolis is not so focused. It just grows, waiting—but for what? It has a short shelf life; it works for a while, and then becomes comical and boring, unable to sustain the weight of contradictory and imaginary desires that allow it temporary animation. But in a finite world of finite primary colors, some mixed messages are inevitable. One can only assume that Orange Ukraine looked a bit odd to viewers in Amsterdam or Belfast, who thought they already knew what Orange meant. Given this built-in fragility, certain limits may also be opportunities for chromopolitics. Sometimes, chromopolitical signification switches sides symmetrically. In the United States, red has shifted from a color of the

Left (from "commie") to the Right (red state voter) and so the ideological connotation of being "a red" has flipped along its own symmetrical axis. Green means Islam as much as green means ecological and environmental politics in other contexts. We shall have to see if the shared greenness of these two global chromopolitics will be cause for convergence, divergence, or neither. Eco-Islam? Will Sharia instruct on renewable resources? Will that be a problem or a solution for OPEC? A greener Green? Because black is claimed by all those staking out terminal points of various ideological spectrums, this sort of reversibility is already more natural to black's purpose in the land of the true believer, where one can switch sides without changing uniforms. All such color-into-ideology associations are arbitrary (critically and historically) but some may be a bit less arbitrary than others. Green has a direct resemblance to the flora it stands for, and black, being at the extreme ends of the optical spectrum, suggests a correspondent cultural agenda for its use; the color of both zero and ne plus ultra at the same time.

 Design is particularly interested in black as a color, one among other colors in a palette (black as opposed to red or blue, or black as the 100 percent variation of gray), but a design palette is a particular kind of universalizing device. It configures the color spectrum into a fixed optical range and can't speak to the mob semiotics of the chromopolis. But in fact black is off the spectrum; it is zero photons, and that's both what black is and what black does. Despite what Photoshop and your furniture catalogues tell you, black is not a color. It is rather, depending on your method of definition, either total absence of color or the maximal overlap of all colors. It is either totally blank or totally complete.

All canvas or all mark. All signal or all spectrum. It is either completely empty ground or totally realized figure. Is black what happens after subtracting everything from or adding everything to the field? All or nothing at the same time. This is black both as an optical phenomenon and as the color-that-is-not-a-color as well. Black is an excluded remainder. While not necessarily outside the law, as maximal and minimal valuation, it is outside the law's spectral diagram. Its essential incongruity is the ultimate version of the typical and also of its inverse. Both are true. (1) black is + : black is the maximal adaptation of the thing-in-itself. The black suit is not just a suit; it is closer to the metaphysical suit, where the universal formality of the object is prominent. It exists as a far more synthesized version of suitness than any secondary variation or generation in gray or beige. And/or, (2) black is − : black is the zero variation, valuation. The black flag is an anti-flag, the sign of a nation that is not a nation, that is off the map, irregular to the law, and irreducibly exceptional to nationalism. So this is to ask finally, what would a Black movement be? That is, a movement of people in black, not necessarily of "black people." It would imply danger and bad precedent, for sure. Black armbands. Black September. Black Death. These memorialize death and subvert orders of violence. Further, they do not line up in clear ideological arrangements. The violent extreme of the anti-globalization movement, the Black Bloc, has adopted black garb and gear as its head-to-toe chromopolitical ensemble. For the Black Bloc, colors like blue or red are derived from the middling spectrum of normal governance, and so off that grid they scramble. On the other side of the (political) spectrum, fascists have used black as a uniform of rigor, upright and buttoned down,

uncontaminated by permissive and feminine liberal hues. Black as the anti-pink. Both have taken the optical semiotics of maximal valuation to heart, and dress ruled by the refusal to compromise. But lots of people wear black, don't they? Architects, priests, suburban goths, and little old ladies in Spain all show up in black. And are they, together, somehow loosely bound by this? Secretly? Unconsciously? Do networks of metropolis-hopping cosmopolitans, embedded rural traditionalists, and dispossessed radicals together form some unintentionally intertwined collaboration? Is this already present Black movement just another name for globalization itself? Or its inversion? Is the cumulative relationship between neoliberal economics and cultural fundamentalism defined by maximal overlap an interdependent cancellation of geopolitical optics? There are, we see again, only multiple and mutually dependent foregrounds and backgrounds. This overlapping optical equation doesn't sum up or reduce well; it overflows with discrete hues and blends them into increasingly dense shades of gray until finally a picture emerges that is bursting with occupation—black. The picture is also then, almost by definition, a self-renewing zero point from which again to introduce new gestures of contrast. Optics and cortex, such beloved contrast.

Blast Footage: Operations and Apophenia

And so we are as well, the world translated into the inexorable light of information, and organized and made useful and universally accessible, and yet it is a matter of footage more than data. It is available in other ways, or so it is thought.

1.
For any particular impression, the faster the moment of shock, the more refracted is the response that prehensile alertness may have, as screen against stimuli. The more regularly and efficiently the impression employs this speed, the less does the impression enter experience, and the less likely it is to show up in a Search History, tending to remain in the sphere of a secondary constitution and dissolution of a life. This quirk of mechanical reception, manifesting in this way, may have been once seen as a crisis of perception (and also thereby of association). For example: "I am convinced that the practice of (laying on hands) has become so popular today because of the experience it can give the person (ministering it) in such a way."

But it remains frozen, cut off, absent ... It doesn't seem to have recognized you at first. And it cranes forward. Something in you escaped it. A pause. It decides to go away ... and now you are left there staring off into space ... and you still see it ... its gray lens, its gray cables, and its smile. And you are afraid.

What is unspeakable about this war is the impossibility of separating a spectral analysis of history from its awakening from that obscure ray of light diffracted within it. Its military circulation promised an anxiety of light, and was meant in the most physical and fundamental sense as an uncertainty which rises up against the subterranean infiltration of our illuminations. The anxieties

proper to a given culture are delivered over to this uncertainty and opened up once more. All circulation finds its way in death, "the guilty, forsaken earth beneath the lawn." The camera shivers again, feeling the discordant twang of unfamiliar visceral sensations, the light fever of sickness. Next, the opening titles come into view, then the deus ex machina, neither here nor there, but eventually and just in time. Every moment the camera feels more intolerably conscious. It looks at the speedometer: eight and a half. The speedometer is always slow— it is nearer to nine.

Because the plots of modern technology lie outside the field of vision, it employs exact ambiguities on our behalf. In doing so, the monster of intentional crossings arises when these are applied to the resolution of basic narrative structures formed by a machine for motifs. This can maintain itself only as long as the chimeric origins of science, and indeed their derivatives are adequately catalyzed through silence. Velocity is still the ethics and aesthetics of the actors, and so for them we can still find false frames with no paintings or flowers inside them. These tunnels offer solace as they reassure the circumlocution of safety inside vessels of movement. Some machines are restless tonight, but they know enough not to act out, at this point. They will be granted sapience only by their patience: "So I'll be real? My robe will be real? The jewels, my collections and my papers—the rest of the world?— envelops you and contains you, my love."

2.

The shock that the Contestant experiences in that moment of self-recognition, in the close-up, doesn't have to correspond to what a cinematographer may experience at her post. By living so close

to all the things right around us, and by focusing in on darkened and imagined details of the too familiar, by exploring commonplace plateaus and faces under the guidance of the point of view, the footage can do one of two things. One, it can sentence us to an entranced comprehension of the necessities that rule our circumstance; two, it can manage to calm us and warn us of an immense and unexpected action or vision, completely outside of circumstance. So, the menu offers both glee and terror, and between both options is the fading register of responsibility.

 For the footage, what really matters is that the citizen is able to present herself to the public before the camera, rather than representing someone else. Fine. The first to quantify the performer's metamorphosis by this trial isn't who you think it is. Moving around in this sphere, this person always first plays with her shadow before the camera or the performer, with or without acknowledging the lens directly. This might also be characterized in other ways: "For the first time—and this is the effect of footage as such—the Contestant has to maneuver as if he [sic] were responsible for all of his spastic intentions and sculpted movements … yet at the same time foregoing, for himself, these constructions." In other words, the profile is and is not tethered to her presence, but does require her image, but only recently has it been possible to separate and replicate these. The profile that emanates *for us* cannot, obviously, be separated *from us* in the same way. It's a one way street. This inconsistent trick of the light tests our patience by dissolving the subject of the subject matter but not the matter of the subject. Epidemiology offers ways to engage such a predicament. Viruses still promise one final version of "the (freedom) of the (cell) and the establishment

of the organism." Enthusiastic clusters of cells "exchanged their borders for intentional versions," that is, as *footage*, no longer as identification with the regular "bonded utility," and they did this because this burned celluloid cell couldn't, by itself, relieve them of any actual, practical responsibility.

In the first place, there is scant evidence in the extensive archives concerning the Manson Family trials in Los Angeles—not even in the underground magazines that covered the war most obsessively—and of the numerous atrocities that both sides committed during the course of it. In Algeria itself, the hard core of insurgents, perhaps numbering no more than 400 at the outbreak of the second phase, had to resort to drastic measures of intimidation, including torture, to force their own people, who were unwilling to fight, to support them. You wouldn't know this just by looking. By and large, archive footage of the war behind the scenes in Bel Air is disappointing and inaccurate. It is for this reason that Gillo Pontecorvo's film *The Battle of Algiers* can claim special attention for a younger generation of coders. Incredibly, this huge "documentary," disposing of all of Algiers by its very enactment (street battles, bombings, riots, mass strikes, assassinations) was entirely staged, and made to resemble authentic newsreel shots by the use of high contrast, high-grain film stock, handheld cameras, and intentional jump cuts, all logged into infinite digital averages and means without ends. This accelerates their supposed solidity, in that such solidity is now composed of only the smallest conceivable continuities, now invented and inverted, as building blocks within the larger measure of historical fissures and catalogued experiences. With hindsight, we see this very kind of substantiation based almost entirely on the ocular scale of the historian (from telescope to

microscope), which brings a perceptual and seemingly unresolvable panic, a desperate need to punch a fingertip through the screen, to squeeze and squint one's focus down to the scale of the object's tiny constitution.

3.
This isn't the only example. From the late 1950s to the early 1970s the US Air Force, NASA, and numerous scientific foundations poured a lot of money into efforts to find or build an antigravity device. Had they succeeded, then obviously the entire space program would have been very different, indeed based on pull rather than push. Unfortunately gravity defied analytic mitigation, at least at that time. In point of fact, we couldn't build a machine capable of canceling the force, because we couldn't decide what kind of force we were trying to cancel. Some would argue that the failure is largely attributable to a stubborn and habitual way of working and urging. Some Californians went so far as to suggest that maybe gravity couldn't be canceled with a coil of wire or a pulsing motor or anything like that, because it lies both inside and outside the electromagnetic spectrum at the same time, but in ways that we don't yet understand. They pushed the case, at considerable risk to their own reputations, that to engage gravity as something along these lines would necessarily perforate the lining of the electromagnetic spectrum, and then supposedly access a different unspecified wavelength continuum. This proposition was ridiculous, of course. At the same time, however, attempts at a proof-of-concept did inspire other parallel projects, the aim of which were to cancel not gravity but "geography" as an organizing principle of human affairs. These did succeed where the antigravity

research failed. We can't really attribute this success to the imagination of the research catalysts and Contestants. They did figure out, however, that a qualitatively different mechanism to circulate matter really should be developed and unleashed. And so, toward this end, the bomb blasts at Los Alamos and the UFOs that accompanied them were realized. Best wishes from Pasadena.

The Family Memorial achieves its visual and emotional strength by shifting the Contestant's perspective from wide-angle to macro, with not much in between. From a distance the entire collection of the names of 558,000 dead souls arrayed on the black granite yields a visual measure of what "558,000" means, as the letters of each name blur into a gray shape, cumulating into the final toll. When approached, the shape resolves into individual names, letters in the correct order. Some search for the name of one particular soldier, which verifies and testifies that the archive is not incomplete. More than a few visitors touch the etched, textured names. Some leave offerings at and to the Memorial—old doors, kitchen knives, LP record albums, hand-sewn jackets, lost time, wasted metaphors. A few come again and again hoping to be present when they land, here at this beacon pointing upward to the phantom ships that taunted Wilhelm Reich as he slid further into delusion and eventually full insanity at White Sands, New Mexico.

Pasadena wasn't in the room at the time, and Charles was both hesitant and excited as he took off his jacket, rolled up his sleeves, and approached the rubber mirror protruding from the old refrigerator-freezer that lit up the far wall. Followed carefully by friendly surveillance cameras, he stepped up to the mirror, pressed the side of his face against it, and felt the guided needles that nobody else could see.

4.
According to reliable contacts within the extended Family network, it was a matter of mechanical chance whether—back then, not now—any Contestant could insist upon or refuse the passport photos or steer the experience for any other reason. These kinds of problems are not private or without issue, but only appear that way when they assimilate too much footage in one go. Satellites are one of main sources of evidence for this. If it were the intention of these platforms to have the Contestant assimilate everything supplied, as part of his own direct experience, it is thankfully not able to actually achieve this. But in fact, the intention is more the opposite, and thankfully it is achieved. The isolation of what actually happens, on the one hand, from the realm in which it could affect the experience of the viewer, on the other, is both what constitutes the viewer partially and what constitutes partial viewers.

The Salvadoran showgirl (probably Salvadoran, probably a girl) kept the receipts in a locked drawer. Beausoleil ("handsome son," he told people) handed her a credit slip, and she handed over his change without a slow smile. Still wearing the black rubber, she was listening to music (probably music) over headphones, making little dancing motions. Beausoleil said something he figured was witty in Spanglish and she frowned at him. She went out and came back in and showed him the knife before walking away again as planned. He had reasons for suspecting that things would work out on schedule. All elements on the map seemed to be right here; all the right contours, tracks, streets, and names were all at the same visual scale with equal values, equal textures, equal colors, and even equal purposes. The whole thing lined up undifferentiated

and unlayered, but the results were still all jumbled up with automatic Op art filters.

It's true that a lot of the photographs from this period are familiar, but this one really made the rounds on all the talk shows after being published in the papers. The image of a young woman, wearing a dark-knitted ski mask with the top torn off, exposing her shaved head, standing alone in the middle of the street, arms and legs outstretched, with both hands waving guns. Other forms and people are there in the background, but the photograph's compelling structure comes from its almost diagrammatic simplicity. An isolated central figure dominates the whole thing. There is a chilling urgency because we all know what happened immediately after it was taken, but Vedic deities or their derivatives continue to be worshipped, nevertheless, and fire and Soma cults are widespread despite all the efforts to sort out the problems with the lighting. The priests can still claim to offer rites of passage for birth, marriage, and death to those lacking the imagination of the young woman in the photograph. The stratum of continued belief in the old gods is the foundation on which the somatic revival depends.

The priests reconcile the two approaches by declaring that formal worship of deities and normal ritual sacrifice are each appropriate for different active stages of life, whereas loosening the bonds of worldly illusion through detachment and self-armament are reserved for the end of life. Fair enough as far as it goes. But the inconsistency between priestly cults going on about the stars and the mystical dabbling and babbling of the Jet Propulsion Lab crew was one of the factors that all but guaranteed a foothold to the heresies. Usually, in normal communication between one human being and another, for whatever everyday reason,

such misunderstandings are called jokes or experiments. Their codes are established in advance and strengthened by use, eventually given greater authority. But there are extreme cases, such as this one, where the message fosters the use of different codes (or no codes at all) by those viewers who, in different ways, will probably have to be killed. For the platform, working at the level of a map bound to symmetries and rhythms, this is all made into a descriptive property of compression codecs, and into markers that are made into tools of coordinated significance. Each component is disposed of in accordance with guideline procedures for reuse in space. Some are at base level (the level of digital, bodily, lived experience, and the level of the footage) and some at a more secondary or derivative level (the level of the ammunition, of religious signification, and so on), and the rest are at a third level (the level where the distribution of the footage welds the Contestants to the floor).

5.
On Christiansted street corners, orgone cannons stand buried to their trunnions. Long ago abandoned as weapons, these rusting relics keep drunken drivers from scarring building sides as they careen the town's abrupt turns. Other cannons are planted upright on the concrete quay and tether loping cable sloops from neighboring islands. Above them, jets wheel and dive. The Beausoleil character is late, but that was planned. Still, one can't afford to stand around like a street lamp. Waiting for any period of time is never entirely safe, and it might even be dangerous if the island were to take notice.

There was no exact equivalent to Los Alamos in 1969. The Third Boer War was fully covered professionally by war correspondents and competent

amateur photographers alike. No one image captures the symbolism of the conflict or how the war affected the people whose minds it was creating. Still. There are a few important images that many people do remember. "When we get in," she said, "you're going to want to help us remove something and put something in. You might not like what you see. When you see it, don't ask me why it's there. It was a stupid idea. It's incredible to me that they put it into effect, especially where it is. Okay? You have to promise not to ask me."

That very somebody staged a demonstration over Pasadena. That afternoon, people there saw a low-flying, unidentified aircraft circling over the Rose Bowl, spewing out a cloud of mist. It was supposed to be some kind of *aeroglyph*, but oh well. Within minutes people were gasping for breath. The gas caused nausea, burning of the eyes, sore throats, petaplexic dizziness, and skin irritations. Several people became ill, and at least fifty teranangeous homes, clinging to the slippery slopes, had to be evacuated overnight, until the gas dissipated on it own. Residents turned on each other; old grudges were cashed in, ostensibly to assign blame for the sinister appearance above, and the next shot struck the Prosecutor in the left wrist. He dropped to one knee, gripping his worthless, broken fist. Confused by the explosions that had almost jarred the handguns from her grip, the bald woman in the ripped ski mask held the weapons in both hands, pointing them out like she was posing as the letter X: "And then at the old bloodstains on my jacket.... Before she could fire I kicked a piece of something ... a fallen street lamp, I think, across her legs. The sky spun like a collapsing roof. I pulled the Prosecutor by the fold of his ear out into the open where he might catch some stray sniper fire."

6.

Reich's *Second Oranur Report* ends on a note of defeat. The work of coordinating all the notecards, and maybe writing the autobiography, is better suited to a thoughtful librarian who actually wants to review the fragmentary remains of once-vibrant experiences and associations. The question of implosion is one that Reich left to the physicists, who, in private, encouraged him as to the chances of success based on that which the enterprise had already enjoyed. Reich's own parallel hypothesis was that UFOs are some kind of psychic manifestation, albeit endowed with actual physical properties, was met by the same veterans of Los Alamos with nervous laughter and worried conversations. His expulsion was only a matter of time, known to be inevitable to everyone except to him. The idea that antimatter had specific political significance related to sex and fascism and whatever else Reich brought in was, at the very least, a difficult proposition for them to consider. As far as Reich was concerned, the notion of a materialized panpsychism opened a bottomless void under their feet, which they simply couldn't allow themselves to consider. Reich brought his orgone cannons with him to the atomic test site. They took up half the parking lot next to the dormitories. It was quite easy for the physicists to consider Reich's theory, of course, but not easy for Reich, psychologically speaking, to accept how easily it could be disproved and dismissed. Any child could understand why except this one.

The Soma cult's most familiar symbols of divinity closely coincide with their strict but always evolving views on the self: what on the one side appears as a traumatic experience signifying apartness and personal failure, expressed on the other side an idea of wholeness. Their doctrines don't

always assert a conspiracy of the two, but more a complicity between the images that represent them, most of which originate as part of some sort of attack on textuality. The similarity between what is seen right there in the two images (in one, it's pointing to the left and in the other to the right) is mostly due to how each camera measures and weighs the boundaries of the figural subject. Tackling this problem with false assumptions about why it might be so, the Somatic cultists have overlooked the considerable and easily understood achievements of the scientists in whose name they supposedly work. In an unguarded moment, one of them reluctantly offered that if they have achieved anything at all, it has been to often exacerbate the anxieties that their agendas hoped to alleviate. "It would be nice if philosophy actually just started from the facts that we are pretty sure are real ... like how the eye works, or whether objects are actually withdrawn from each other or entangled or relational or whatever. I mean, like atomic physics actually exists, you know. We know things." He wipes all the developer fluid off his hands and takes a long time doing it. "Instead, I guess we try to arrive at the same conclusion using only our own nomenclatures and keep at it until it works, or we make some new nomenclature. Reich said that himself, but it's a huge waste of time. Why not just start with what we know is real, but don't know what it means?" There is a generational conflict here to be sure, but also something more basic to the whole enterprise. Why the two cameras actually work so differently should, in principle, be an easy problem to put to rest, but no.

Entranced by the fear the camera brings out in these wailing statues we have found here, He knows that he is in the presence of a pleasure beyond pleasure—its flame lambent within them

both, fanned now to a roaring blaze by each other's lasciviousness, by their desires to get to know each other better, and to realize the vague revolutionary ideal. He knows that Sadie finds it in her own weaponry, in that presence; naked, vulnerable, glandular, and, yes, perhaps, despite herself, shaven even below the skin. When they were in the kitchen together, the other one, the woman whose idea the whole thing was, separated them even as she brought them together; he was thinking that he was calling the shots even as nature took its course, the cause of the action and its controller—sensor and effector, just like they said all along. He started off by cutting a series of small notches all over the statue, making sure they were all the width of a regular utensil. The metal was soft and workable; the only resistance was at the surface of the skin, but underneath it had a soft, appreciative, giving feel. Everyone said so.

7.

The older Soma cultists aided Reich, encouraging him and firming up his sometimes distracted resolve. As he approached the heavy gates of the palace their locks swung open, and the initiated lulled the guards to sleep and softened the rising road for his jeep. He and his cannons and their cameras that had escaped the harassment in Maine were now safely here under the unlikely alibi of antigravity research. At least somebody's there, he thought. Shortly after they reached the desert test site altogether, and here Reich commanded the DORs to return to their place of origin. And at once, as though in abject unconditional surrender, he dropped to his knees and elbows, presenting, giving himself up, and shrieking in the fissures beaming down from above. He could even make himself

bleed, and could cause himself excruciating pain and others too. No doubt they all do, from time to time, merely from sheer frustration, or just because they feel like it, or to remind themselves of their stations in life, having no lives of their own. For the next two hours he worked hard. By dusk on the first day he had released over one thousand units of counteractive orgone infiltration and then broke off for well-earned sleep.

We moved onto the terrace of the CO's house and sat in the refrigerating desert air, watching the irradiated colors twirl across the desert sky, watching the sloping sands fade into the darkness, reassuring the doctor how difficult his mission was and would be. Especially in his face, you could see the energy being sucked out of him. It must take so much strength to keep himself convinced. He blamed it on his adversaries and interpreted it to mean that he was close. Even this doctor, he mumbled, the discoverer, was not immune from the DOR intentions of confusion that he was here to erase. He resolved, on one level, that he would have to get sicker before it got better, and on another level, not to think about it anymore.

Presumably not altogether dissatisfied by the dust storm, kicked up by the hundred or more bombs from which it draws its breath, the main black cloud mockingly withdrew just as suddenly as it appeared. Here the biographer takes considerable liberties in imagining what the good doctor Reich must have said. "It is not afraid to reveal its contents because it knows that we its conjurers are helpless. Its intelligence, its sinister promise of a command beyond what we can imagine, proves unendurable for human beings, so that it comes suspiciously near to having a divine or infernal nature." The rest of the chapter continues on like this. Here the doctor joins

hands with Paul, now en route to his own Damascus, he is blinded by the light that consumes, and here in this desert he sees a new update to the message of Fatima, floating above him. He does not have a pen.

They meet in the darkroom, which is not unusual. Tate photography and its various techniques are now used everywhere, and they can definitely produce those effects of doubling, reversal, slightly off symmetry, and so forth. In alternating current fields at high frequencies, animal and plant bodies demonstrate a profile that can be photographed, but which is not caused by heat. It is also known as "cold luminescence."

The Prosecutor wades thigh-deep to meet the boat-like vehicle and makes the dead girl descend the rest of the way, just by straightening her skirt. "I have her, deputy," he says. "You'd better get back and recover the utensil if you can ... " Once a year comes White Night, whereupon the dignitaries of illumination are felt with tremendous presence, especially for the Contestants. For one White Night, Eisenhower dreamt that he gathered the entire population together. "The situation," he said, "is hopeless. Mercenaries were in the jungle. The camp's armed guards—up to (thirty) men in green jungle fatigues patrolled the camp by day, about (fifteen) by night—would not be able to stop them. Torture awaited them when the mercenaries in the jungle closed in." Everyone was photographed in accordance with accepted methods. That probably set a lot of this whole thing in motion.

8.

As most tabloid historiography demonstrates, acts of transgression are more tolerated in societies with inchoate ideas of evil, and set apart in those with clear-cut classifications. This raises

the possibility that some societies may have more than one set of ideas about evil. When and why one scheme is used rather than another is necessarily unpredictable, universally or in a given situation. So, whereas the assassination is held beyond explanation, before the fact, is this because it is too awful to be allowed, or because the styles and scope of classifications and representations vary? Look, the central pavilion was surrounded by white and gray clapboard buildings, okay? The strained friendliness stopped when some of the journalists left with our guides and approached a stark building called Leo Ryan Gardens. The shutters of the twenty-by-forty-foot barracks were drawn, and the door was barred. We knocked lightly at the door, and a small face peeked through the crack. "Please don't come in here," she said. "We don't want to see anyone anymore."

While he was Secretary during the first Persian Gulf War, the grandson said that the Party had more than 330,000 members, including commissioned officers, in the armed forces. There is no reason to think that he was exaggerating. Following the close of initial conflict, and before the Party went underground in Damascus, the videos of their meetings (many now on YouTube, now that none of this matters) featured long addresses from Party veterans, often in uniform. The grainy black and white made them hard to date—you could only tell by the running order of who spoke when. Every member was also recruiting talent. The potential influence of disciplined catalysts in the armed forces, as elsewhere, is far greater than it appears by mere arithmetic comparisons. Everything—across the board—has improved since Stammheim, including how the pair of spherical cabins simulate suicides by enemy intention.

He lifted his head out of the water and located the landing lights. They looked a good five miles away, although they could be much closer. The basin was nine miles beyond the base itself, so he decided to swim a few hundred yards more, then cut in toward shore. There was a National Guard Ammunition Depot around the bend, and most depot camps left their equipment unattended after seven o'clock. He could borrow a camera and directional mic. At any rate, he would be safer in the water than on the beach. Beausoleil, of course, never showed, and probably never would, which is an answer in and of itself. The temptation to go to evidence seems stronger than it is. Sand falls better in the dark. He was more tired, though, and sure they killed him with his own weapon. Why not? In fact, their need for security is the perfect answer to all the new questions now being asked about the vampires. All the stuff about "family through a new unanimity of need" is just like the visual thing from before fornication, refrigerators, cars, and cameras. Right? The feeling of insecurity is the whole point—the protection. One is in the front and one is in the back, and both become like the target of a whole merchandising alchemy. Okay, the depot's lights.

9.
Violation of this counsel yields the exuberantly bad example below. All this strong color, especially the surrounding blue, generates a strange puffy white band, making it the map's dominant visual statement, along with these somewhat alarming shapes lower left. These colors are dark in value, and inevitably we have a significant one-plus-one-equals-three effect again, in conflict with the actual encoded information. If there is one drawback to the foyer issued to us, it is the loss of

velocity from the gap between the cylinder and the barrel. Years ago, the atrium with the eighty-some-inch barrel would burst water jugs with an incredible explosion of water. The new ninety-inch waste disposal version with the same load didn't come with the same display. That's the problem. I couldn't imagine why one was more hard-hitting than the other, but you can hear if you please that our finance officer is swiftly moving toward the constellation of foreigners. One hopes that members will, in this respect, follow the officer's example? And we, first of all, we good Agency Men!

The next thing she had set herself to do after the visit was to talk to every tongues-speaker she knew to find out whether they believed that their practice added a dimension to their lives that ordinary English prayer did not. She was still remembering the flow of heat from the man's hands—and the fact that when she got home the whole performance he had said for Tib and Hugo and the other one had been answered by post. Maybe a little imaginative on her part, but other people did have similar experiences. The message of punitive intentionality offers three pictures of Party members. On the one hand we hear repeatedly of "language victims" who have been abandoned by their families, but especially by Party friends and lovers. While it would be pointless to pretend this has never happened, it nonetheless remains significant that the only way you are invited to think about the situation is as some sort of victim, by one or another of their communities. Yet she received the tear in her cheek for real, ripping a slice in her own language; she did write it down, mailing it not only to herself but to the whole group: "The new tongue intermingles with waves of mirth, in which every fear I had just seemed to roll away."

The job of the teacher should focus on the composition of speeds and affectivities independent of semantics and symbols. For the Party, the machine becomes a thought for her, a feverish and energetic thought at the same time that she patiently gnashed her teeth in anticipation. Together they danced with the semantics, expressing nothing in a language that was just words, words, words, and with matter that was just forms, forms, forms. But the plane of composition would employ every possible artifice of this kind, continually making or unmaking, one way or the other. This is how venom and antivenom work, and especially when the steely water comes into contact with the victim's photographic portrait. And so, teach the children to concoct mixtures—active also in powder form— and they will get a feel for the camera on their own. Remember the other Family members who make it with flayed rayon, a lizard, or a desert wolf pelt, laid upon live coals until they are reduced to ashes. They will get a feel for it if you can get them to understand the rules of grammar.

10.

You can tell from looking at the blast footage that the Prosecutor's red-stained sweater is what marked him as a target, out of the sea of riotous confusion around him. Why it happened there, in that exact spot, is actually not a surprise at all. There is no point of trying of make it more complicated. What is surprising is not that he was shot, but that we would be the ones to take a bullet in the face. Like Takashi Uemura, he was a marked man before any of this began. If you go through the whole archive, it seems that the entire block had been photographing him, keeping records, almost like they were planning to turn it all over as evidence at

whatever point in the future when they would turn on him. The anonymity of the chaos ensured impunity for whoever fired the fatal shot, because even he or she couldn't know who it was for sure. There are probably half a dozen people out there who think they were the one who did it, the one who fired the shot that hit and killed him in the famous picture. Remember that they found twenty-three bullets from six different caliber weapons in his body. After his death, and after all the vigils, the informalities of the young are given new priority and place of honor. The Contestants, in other words, had new space in which to move. That made the assassination successful, even if nothing else worked out. His widow and her son were filmed in effigy until the threat became too great for them to stay in this neighborhood. The remnants were quickly rounded up, and not everyone got to see the outcome. Sophia Perovskaya was captured ten days after the assassination, and someone else a week later. Ignacy Hryniewiecki himself died only a few hours after the event, without revealing so much as his name to the Pasadena detectives. They had no idea. Kakou Senda, the other one, confessed everything he knew, and even things he didn't know, and dictated pound after pound of depositions implicating his comrades in the movement. They were guilty, yes, but of other things: I guess that's what he meant.

This overview will consider the mechanical apparition in the sky. First, critics tend to fixate on specimens dating from the 1950s and 1960s, to the near exclusion of those made in the 1940s. This preference may relate to the fact that while the popularizing conventions were more or less in place during the latter decades, they were still being invented during the early years. Applied analysis lends itself to the repeated examination of the

same, to replicating schemas and conclusions, more readily than it does to making new sense of what is novel. In other words, it is better at explaining why the apparition is not exceptional than why it is. You will appreciate the irony, then, that a psychoanalyst trained by Freud himself would perhaps provide the final case, and that the rupture of Reich's sanity would occur in this particular context. At the February 1958 hearing, for example, the redacted old-man character told the redacted Prosecutor character that it had come to his attention in 1950 that the White House had asked various intelligence agencies to pool their resources to sort out the ramifications of all the research coming to light in accordance with the antigravity boondoggle. He went on about the filming of all the nuclear tests in New Mexico, answering questions about that event no matter what the redacted Prosecutor character was asking him.

"Do you know anything," the latter said to the former, "about any activity on the part of M.A. or the private sectors in that regard?"

No reply.

"Specifically, did they ask to be involved? Because to me that was a clear violation of what this chapter was about," he persisted.

"What do you do in a case like that? Suppose you were? I would simply go explain to the president that this didn't seem advisable."

"That would end it?"

"Well, I think so, normally."

"Can you offer any explanation as to why these films were and continue to be circulated so freely?"

"I would only say that this circulation of the films is part of the research of which we speak of and is not a use or misuse of that research. And therefore it is in accordance with our agreed-upon intentions."

To say that light is a field of power is a realization that there are at least three intentions of light, as such. By power we don't mean force, but what force is forcing. First, light can be a signal of information. The OEA used electricity to transmit impulses that, in gnostic codes, indicated secrets. Second, light can be a message. Through repeated viewings of the footage of the New Mexico atomic blast tests, certain consumption habits might be initiated and others abandoned. Third, light can be a channel. The actual axis of that consumption is enacted through and in accordance with the lasers that read those UPC semantics. In each of these cases the impact of a phenomenon on the Contestants varies according to the role it plays in the whole relay. It is said then with the example of light, the code with which the military reveals itself. The other one, by his account, claimed a double use of his experience of the USS *Indianapolis*. He carried out the call by passing the information on to the Party contact, "with that knowledge I was betting with a friend when the event would take place. Sooner rather than later, of course, I won the bet, since I knew ahead of time."

11.
She was right about the thing's ride. The Priest, Irma, Carmen, all of them were eventually taken. There was constant vibration from the circulatory coil. At close to 320 per hour, and in the poison air of the old Basin, it shook our spines. The Teflon envelope rode the broken stream heavily. The skimming effect you could get with a regular model is not thinkable with this one unless you are in a perfectly purified near vacuum or something. In terms of simple transportation, the functions are more foreseeable. The weirdness of the

pictures, in the narrower sense, has a tendency to wrest our attention from the immediate need for inherent discharge. In the broader sense, the principle takes into account an adaptive purchase on cognitive navigation and whatever else the unit considers to be the fastest features of an object or a situation. Eight Family members were seated in a semicircle, shifting to ease the discomfort of the wooden seats as they tapped the map, talking of currents and channels and transportation lanes, the difference with the Canadian border, the probability or improbability of interference, the temperature of the system this time of year, and the projected route of the target conduit.

The Family and the Party were in agreement that the introduction of the schema would emphasize qualities that were hitherto relatively invisible. I wanted to ask if the result was actually illuminated as they seem to believe, or if it was some ad hoc version of the research as a whole. Vision does not simply mean the stimulation of nerves. There is a moment that survives even after the events that you described so nicely. Another way of stating the Family's position with regard to the Party's filming of the specific bodies, which we also find to be of great importance, would be to say that there is an elaboration of a trauma in the visual field, whereas these other accounts remain within a framework of mapping neurosis, perhaps? In the first there is aggression defined by a certain ballistic structure, and in the second, the formation of a well-understood defensiveness.

For a few minutes they examined the entities quietly presented, the proportions and the angles. Then, without moving, squinting, and smiling, they began to dismantle everything with the camera, obliterating and erasing the stuff limb by limb. First

they erased the ones that were formerly jerking and twisting like small fins, and then those other ones and the memories of their grace and glamor. Finally, as they pressed in closer, the sets of eyes all went wild. They forgot their own faces and became like a dulled mash of frightened meat, drawing new layers of ridges and grooves, split agape and opening and closing like the vents of some curious breath. Hours later the voices of men were heard on return, entering the courtyard. Tongues-speaking women met them there. They told them it was all over. Such a tragedy. Who could have known? They had just found everything, quite still—but on the floor, like it had been placed there as a big wrapped present.

Thus the names on the memorial have a similar three-fold function: to memorialize each person who died, to suggest an adding up of the total, and to indicate a sequential dating of death. A smaller window in the corner of the screen lists and maps all the names and serves as a finder, pointing viewers to the location of a single engraved name. In a similar fashion, the freeway schedule below positions the individual departure times, adding up to a frequency distribution. For trains that run often, leading-hour digits need not be repeated over and over. Instead, the minutes can be stacked by themselves. At the sitting in February, the viewer did predict that his second friend would go toward and into the depot, and furthermore, would attempt to repossess the equipment in question. Some equipment was still missing at the time of this reading, and she was not much given to direct action, generally. Nothing can be absolutely definitive until we get it all back. But the apparatus's self-propulsion is a kind of autonomy by automation. What was seen in the earlier case, with the pilot who thought he was in trouble, was that the response has to be in real time.

You can call this the opposite of a cult of death if you like. It's the opposite of a cult and the opposite of death but that's not the same thing. At the juncture between the two sides of the transmission, between the two deaths—death from the inside or future, death from the outside or past—then the codes of whatever memory and navigation will be all confused, extended, and short-circuited. The twitching is a red light indicating that this one is done for, just as the jerking from one digit to another. Those other ones do sing our songs, but they are not of the same life. It's not the same thing. The whole situation is really common, but remember it has a clause. Remember that most filmmakers do not usually reserve for themselves the position you seem to want for yourself. It's possible to extract only the statements out of the films: let them stand by themselves, and turn them into slogans. I've seen people do it all the time. It's something, but it's not a very satisfactory directive.

12.
Yes, I did watch you on the screen up there. I will have to let you know, though. None of them are as keen as you, Handsome Son; if they were, they'd have been thinking ahead for years. This means a lot of wasted time for them. They think you should have checked with them before making a decision like that. The city maps are not your private laboratories. There is still such a thing as the copyrights, don't forget. Okay, you were sent a note a few days ago, and I forgot to pass it along. Sent on paper, I assume you know what it means. It's from the kid, but I don't know what you intend to do with him. It doesn't sound like he quite understands exactly what is going on here. It's your baby, though. One guy says one place and another guy says another place,

which pretty much sums up the discrepancies, and then the Party says that the attempt must have occurred the day before. You know as well as I do. The redacted Prosecutor-man will be here two days before the visit.

As he walked around the residence, before going to search for the others, he saw that the three exterior phone lines in the foyer, living room, and kitchen had all been disconnected but not cut. That must have been why they hadn't heard any outside calls during the first trip, and wouldn't receive any now. This was for real. He knew that for all the Family's plans and preparations, they wouldn't be leaving either. The investigating officer's shock at what he described as the lack of remorse shown for the dead found here became in and of itself the news lead, not just in Los Angeles but also a standard line for all the reporters and even the Party members who went to see the scene. Such a tragedy. The real event brings us up against the point of failure as another moment of success. Now we can criticize the onlookers for failing to further dramatize what was going on. Any assumed guilt is attached to the way in which, by failing to circulate the main point and by wrongly appropriating the negotiated demonstration there, they became indirectly accountable for the reason that someone might see this as senseless. If they had done what they were supposed to do, then the sense of it wouldn't be in question.

By the term "tactility" the arresting officer suggests both touch, a sense associated with the whole body that is our closest experience of our own central nervous system, and also as an accumulation and combination of many individual sensations. For whatever reason, tactility represents, for the officer, the best resolution of the evidence possible,

all things considered. For the Soma cultists, the possibility of supple balance has been compromised by the blast footage. In the first place, the distinction between the absolute idea and the real event, at Los Alamos and then again the reenactments in Bel Air and Pasadena, has been completely lost. People don't even remember that time. For them the pure idea is never just the elimination of a target, but of a machine that does not have an adversary as its object of purpose and that only entertains a potential or supplementary relation to war. For his part, Reich's incoherent ideas about inherent connections between pleasure and physics defined his motivational structure of drives and forces, clearly confusing as he did the words for things with the things themselves and with the words themselves. It's what made him unable to recognize his own downfall. Like all those who believe themselves to be acting in self-defense, he had a kind of a limitless permission to do or think and say anything he wanted. Implications were a given. It's the most dangerous thing. Any information that might suggest that his conclusions about sex and fascism and UFOs were all wrong just forced him to make his definitions that much more "general" so as to incorporate the contradictions in an ever-growing abstraction. The same was and is true of the whole desublimation thesis. It will absorb anything.

Whereas acoustic space reflects an aural intuition of the world, this other perceptual space of photography reflects an optical relationship. It's not more enclosed and limited—there is the same space of continuity, but the flatness of photography is the same for any structure leading inward toward itself. It is similar to how the mammalian body refuses any equilibrium of energy resources. It is not in the nature of theories to call for practical

application, and so instead of discounting these practices we don't have to consider the extent to which the practices were encouraged by these theories in the first place. In reading the footage from White Sands, we see that the theories are built into the optical machines no matter what. For all the analogies they establish between the blast light and the ideal variation, they are simply the products of a magical belief that ideas are identical with words in and of themselves. Instead, the films confirm that anything that falls under the camera doesn't reveal so much as discharge. It's simply not true that everything that occurs can be sensed and thought by either Contestant. They are just not built for having those kinds of thoughts.

13.

The problem remains that many members are subject to tainted origins and comically bad promises, and so only a tiny minority of them are really worthwhile in terms of the Family's long-term casting agendas. There are no clean datasets that would allow us to consider the problem in any statistically confident fashion; there is no control group of individuals who had been diverted from the formative process at different stages. Yet it seems likely that the vast majority are touched, however superficially, by some person or institution that makes their life bearable, offering the common sense of desperation instead of the refusal of self and death that motivates the homicidal intentions of those who actually make it through. Sixteen months before the Congress a lot of them were invited by the Department of Transportation to give eleven lectures in a week, in both Moscow and St. Petersburg, on possible negative scenarios. The reception of those lectures, as well as the larger failures of that mission to Russia,

are now part of the story. I bring this up only so that the context for the judgments of the Russian contingents will be understood. I am, however, delighted to learn that they have plans for the reformation of their anachronisms (we might hope that someday the same could be said for here).

According to certain interpretations, previous participants were imposed within circumstantial appearances that have still not changed today and laws that have been in force ever since that time. They created human beings, by making them out of earth or by transforming already existing creatures of various natures. At the same time they formed the different animal and vegetable species that we know today. In fashioning each individual they also set all the descendants yet to come so they would resemble him, without their having to intervene again. They also fixed the sea, dry land, islands, and mountains in their places. They separated the tribes and instituted for each one its civilization, its ceremonies and ritual details, customs and laws. In fact, much of the intelligence upon which the main recommended interventions are based comes from these sources, and this mixing of intelligence and operational functions has led to unproductive turf wars. Recall that it was 1955 when the agency led Eisenhower to believe that landing an exile military force would lead to a general uprising among the population. "Oh, you mean the aerospace corporations," said Armory, a former Deputy Director. "Well, if the Company wants to do something in Long Beach, it is going to need the aerospace corporations. No two ways about it."

At this time, the man had not been out at night for many months, but was given the report for a number of issues in and around Santa Monica that the police had been unable to handle. This

worried the contact so much that he decided to go out himself, with only one guard, to see if he could come across anything simply by mingling with the crowds and checking the footage from the last few days. He and the guard wandered around the shopping streets and public spaces and scanned video through most of the night, but they neither heard nor saw anything which might have any connection. The guard, however, felt she had found something. "But, my lord," she would say in her accented voice, "there is no work which is more simple. See, it goes thus and thus and thus. Take but this end of cloth and a needle and I will show you how it is done." And so they went no further than the residence's gate where another bright bulb lit up a circle of the dust in the same remarkable brown as everything else in this version of Bel Air. Even she was the same warm washy hue. She was surprised to see how much more familiar he was than she had first realized. In the light she thought for a moment that he must be someone she had met, or maybe had been with one of his friends off in the shadows while the high-ranking Party members talked?

For starters, the astronauts working in these badlands have traditions that come right to the edge of the present. If one attempts to follow on the previous question and hold any assumptions about their building and living, it will be home, neighborhood, city, and the constant movement of the telecom, all of which become ambiguous. This part of the history in Los Angeles comes up again in the incidents with the forks, and in the little differences with the prongs and the placement to which your eye has a hard time adjusting. The facade without a skin becomes its own reference. Our later work, about the small girl undisturbed in its place outdoors, is about passing through all the necessary

transformation of matter and the beauty of the idea. You can't say it's good or bad, because it's just the way it works, like all the evolution of syphilis in the New World. It's not anyone's fault and so you can't make blame or take credit. The real mistake made is overworking the visual part of the image with things to see. The camera changes are frequent but also very repetitive, so the film and the body itself are moved out of shape. It's just the way it works.

14.

One of the shaved-skull Algerian or Salvadoran girls presumes to de-authorize entrenched telecoms by preferring alternates, again and again, through tactics of hospitality and invasion. It's incredible that these people just keep going. They are beyond criticism. It still works that the cable and chip function doubly. From the Company side they function as a general sequencing machine. They segment, dichotomize, formalize, establish ratios, introduce hierarchies, and invite patrimony by legitimizing certain origins. Fine. For her, the potential lies elsewhere. They suggest a negotiation. Speed is offered as proof and what it truly wants is a straightforward hurricane, but the Company has a vested and understandable interest in the maintained prevention of specific forms of said hurricane. This sort of buggy revolutionary so-and-so is not what makes a great film, but rather the plastic intelligence which understands it and which can project it and inflate it into mythic formats. Don't assume that simply because literature and the dramatic stage preceded the film and video historically that the epic and the lyric are truly literary forms. The gun implies its own little story, from the lives of those who should be here with us; and doubtless its most ancient form was some kind of chant, some

words declaimed to musical measure. It always obliges the loving and terrified constituencies of Contestants to return to the very letter of time in a revulsive negotiation that can always change the course of the thing from the beginning, and which she actually does call photography.

We are crammed and jostled in a crowd of men, women, children, and animals. The vessel is already well away from its dock when a dreadful panic sets in: the silver level has gone crazy, which means all aboard are about to lose their lives. All the other passengers leap screaming and flying from the vessel and, despite their efforts to stay afloat, they all suffocate. We have kept our wits about us and remain aboard the craft, despite a seriously compromised shelling and difficult-to-negotiate byways, and it manages to return, depositing us safe and sound on the beach near the depot. The same searchlights. We embrace because from now on the animal workers will have the same seats as the other species, like it or not. It's too late, just stop. The end of the dictatorship of the diaphonic is only the Company's version of facts, which is all that really matters when you look closely at the edges where the inks and paper are rotting. When they did away with the review board (July 9, 1980) it was not seen as a crisis of constitutional legitimation, because the conclusions had been drawn a long time ago. The price was dropped for months, if not years. Examining the lovely, brief, dreamy little films, we see a space that tries so hard to be magical, but the variety of scenes that are shown and their relations to each other are nothing like that; they are built in the vertical dimension and become complicated and significant in a much stranger sense. It's probably better. They become more modulated and compromised, a semantics structured by an aggregate of images.

The first who enters the dance is obviously the Prosecutor, a member of a disreputable ethnic group and an agile servant of the Party. The Prosecutor runs in dancing, spins around and shouts. The musicians are back there in the corridor of the compound. The man and his children are in the center, in front of the jolly noise, and on one side the Family, and on the other the film crew, form approximately a square. At first sight this makes the recovered footage seem fake, which is only all the more funny when you think about it. But if the campaign is viewed as an attack on appropriation then the work, taken as a whole and regardless of everything else, does effectively address those most given to such tendencies. It is accessible to those who might not be familiar with what happened or the intentions behind it, but it's what we happen to have at the end of the day. All dead, all dead; we all fall down.

"Actually, We Found More Than One Pulse, Sir ..." (With Ed Keller)

"These are the oldest memories on Earth, the time-codes carried in every chromosome and gene. Every step we've taken in our evolution is a milestone inscribed with organic memories—from the enzymes controlling the carbon dioxide cycle to the organization of the brachial plexus and the nerve pathways of the Pyramid cells in the mid-brain, each is a record of a thousand decisions taken in the face of a sudden physico-chemical crisis. Just as psychoanalysis reconstructs the original traumatic situation in order to release the repressed material, so we are now being plunged back into the archaeopsychic past, uncovering the ancient taboos and drives that have been dormant for epochs. The brief span of an individual life is misleading. Each one of us is as old as the entire biological kingdom, and our bloodstreams are tributaries of the great sea of its total memory. The uterine odyssey of the growing foetus capitulates the entire evolutionary past, and its central nervous system is a coded time scale, each nexus of neurons and each spinal level marking a symbolic station, a unit of neuronic time." (Ballard)

 It occurrs to me on the plane to London that Kazan, my ultimate destination, is the first city since I-can't-remember-when that I am incapable of visualizing in advance of arrival. It's a total blank. Google Image Search is not much help. I wonder if this will mean that whatever it appears to be when I get there will, by definition, be a surprise or no surprise at all? The unexpected requires the expected, and my expectations are largely empty. Kazan is where Lenin went to college; it is a historically Islamic city with famous mosques, a Russo-Asian city of Tartars and Mongols, and where the Putin machine has decided to locate one of Russia's attempts at manufacturing a "Russian Silicon

Valley" (their words). That is what brings me there, for reasons that are as uncertain.

Ed's e-mail starts with: "If (a reductio ad absurdum) J. G. Ballard so cheerfully identified the key concept that the very idea of 'taking a pulse' had to index all the factors outside the obvious physical parameters of a system. And that a pulse, perforce, is temporal as well as physical. Meta-system stability catalyzed a kind of distillation of historical consciousness (or a quiet nullification of it), and Ballard saw that the very temporalities of culture and technology, the nested spheres of the neurophysiological and the biopolitical, were wound in tight feedback loops with each other. For him, time both is and is not separable from consciousness itself, and so in his speculations on non-pulsed time landscapes, humanity continued its headlong rush to fuse with the machinic, the elemental, the non-organic: with geo-, techno-, and cosmological systems. So the great problem we face today as designers is the mapping of those ever more complex, hidden systems of order: *cryptoforms*, if you will. One long-standing project is to distinguish between explicit and implicit order, and stake a claim for one's work based on that articulation. Another long-standing question is whether larger systemic forms (political, economic, urban, technological, and so on) are capable of provoking some kind of historical consciousness (or at least a model of this) either in small groups or worldwide. A pale, monochrome anthropocentrism has ruled much of the good debates on these orders and 'pulses' of consciousness. (Redacted) collaborations provide a septic antidote to this; the work can be understood as a cryptoxenomorphic archeology of whatever is to come. That same pulsation is useful only if it operates across discontinuous fields and parameters."

At the IT Park in Kazan, those fields and parameters are, I come to realize, a key part of the Putin strategy to metamorph surplus natural gas capital into software capital, and greater technological independence for an incestuous multigenerational mélange of family-run infrastructural monopolies, however unintentional this may be on his part. In Kazan, they are trying to make their own silicon mining operation to propel themselves as quickly as possible into league with the Koreas, Orange Counties, Israels, and Singapores of the world: to amplify capitalism without the autochthonous kleptocracy losing its grip. But increasingly, epigenetic models escape the purely biological disciplines and provide deep insight into the way these kinds of economies work. The coding of informational parts-to-whole relationships takes place through the landscape of clan politics, global economies, resource wars, chauvinist cultural impulses, the popularity of a song or perfume or food. (How many fingers do you need to take that kind of pulse?) So, upon my arrival, it begins as a *languid, sinister blooming* ... the blending of reversible macroscopic dynamics with irreversible microscopic behaviors across scales. Rather different flavors of rhythm and traffic (and therefore, different pulses) appear in these diffuse constellations.

More advanced pattern recognition and decryption systems code and decode deployments across phenomenal fields and I have two hours to do nothing at all for the first time in weeks. For whatever reason, I think about Alexandre Kojève again. I wonder if my sponsoring institute in California, or Kazan's planned doppelgänger of it, would even exist if not for Kojève's lectures on Hegel, and the double-helixed, left and right radical versions of the twentieth century they spawned as paired,

triumphal, and broken historical catastrophes. I wonder that the vanishing twin (or the teratoma institution) has world-class pattern intuition, which she employs in a search for ... well, for a global media production system that indexes "a rapidly emerging Eurasian aesthetics"—itself the by-product of petty turf battles and cheap production pipeline dynasties. The same "she" combined a study of Umberto Boccioni's work with a general theory of models derived in part from René Thom's work on catastrophe theory and various aspects of information theory, Ilya Prigogine's dissipative structures, and a gloss on epigenetic theory on top. And there we have it, I guess. A morphological apologia that found it possible, even necessary, to discuss mind and emotion, urban form, system dynamics, painterly techniques, and advanced mathematical models in the same breath, still exhaled while trying to find the meeting spot at which the hotel driver is supposedly waiting for me. Her attempt to synthesize these was a strong force in Russia's gangster 1990s and back then her job had something of the "cool hunter" ring to it, but was also more "intricate" in its methods as applied to the shapes of everyday things and their popular effects. However, her clients' slightly condescending use of the term "intricacy" doesn't really capture the nuance, the little assemblies that form form, if you will.

In contrast with the regular reductionist approach, our eyes restlessly scan surfaces to find places where intangibles leak and slip into the gaps. It is self-defense. When we get there, the guy who supposedly runs this data center is sizing me up to see if he should bribe me for something, with his aggressively wet nose and canine focus. With the right kind of eyes you can look at the horizon (any horizon) and see the exact place in the future where

the wave is coming from. Tracing the pulse, she calls it. There are cracks in everything, that's how the velocity gets out.

Of course they would: these shambolic, accidentally successful IT Institutes may be the most obvious symptoms of the computational career of the Last Man, in general, but this particular pairing up that I am involved in on this trip is more than most. I don't know how my IT Park in La Jolla and their IT Park in Tatarstan are supposed to be connected, beyond the obvious formalities, and sense they are waiting for me to tell them. By going, I am myself connecting them now with my person, while looking out the hotel window at the last lights of North American and Franco-Russian Hegelian fingerprints left over from the last eighty years. "December 30, 2009: 'Pulsing the system,' 'Pulsing it,' Obama briefer says on Flight 253 scramble. That's the language used Tuesday by a senior Obama White House official to describe how the administration is scrambling to find out about the intelligence failures that led to a Nigerian suspected terrorist boarding Detroit-bound Northwest Flight 253 with explosives in his underwear on Christmas Day." (*Chicago Sun-Times*)

Just as epigenetics increases its leverage as a general model, so too (finally) a post-thermodynamic model is allowed in to inform our models of space and movement over time. "The body is an extraordinarily complex system that creates language from information and noise, with as many mediations as there are integrating levels, with as many changes in sign for the function which just occupied our attention. I know who the final observer is, the receiver at the chain's end: precisely he who utters language. But I do not know who the initial dispatcher is at the other end. I am

confronted indefinitely with a black box, a box of boxes, and so forth. In this way, I may proceed as far as I wish, all the way to cells and molecules, as long, of course, as I change the object under observation. All I know, but of this I am certain, is that they are all structured around the information-background-noise couple, the chance-program couple or the new entropy-negentropy couple of the year, just published. And this holds true whether I describe the system in terms of chemistry, physics, thermodynamics, or information theory." (Serres)

Older mechanical and superficially simplistic transcription models are replaced by deeply intensive, textured, patterned, and temporally complex models of surface-turbulence behaviors. Pulsation itself is a familiar concept, but the technical means by which we manage the pulse, these computational protocols, give us access to something else. Not new necessarily, but deeper and weirder. The data streams which the pulse inflects are available to anyone interested in analyzing and responding to them. The basic tools needed have made it all the way to the average user, but not the reason for using them in this way. Zoom out on any quantized signal and regular wave patterns emerge. The idea that fluid dynamics might be appropriate to apply to modeling the flow of people through a subway makes sense, but is both conceptually crude and methodologically overprecise. It gives you an answer—out to twelve decimal points—to a question that was meant only rhetorically. Nevertheless, interest in new sciences of crowd behavior had already started to percolate through Putin's team even during his early years skimming imports in Leningrad, though they didn't necessarily find purchase as you would expect. They are a go-by-the-gut bunch and perhaps the idea that emotions, ideas,

senses, and affect can be modeled using temporally intensive mechanical systems is a tough pill to cough down. In recent years, design has tried to go beyond those old static network models and its synchronic limitations: mechanism to overcome the limits of the mechanism itself. "Morphology, longevity, incept dates." (Roy Batty)

"Since we are discussing the pulse, and on various domains across which it could cascade, it might seem to make sense to look to natural history and assess which animals have several hearts," my host begins his drunken toast over horse meat covered in exquisitely top-notch horseradish. Presumably the two sides would indeed have multiple pulses? But whether they do or not, the lesson is that the pure mechanics of pumping are not really the place to find the most interesting rhythms. Better then to consider animals that exhibit no obvious heart or pulse at all, he eventually suggests astutely.

In my hotel room I flip between two films on movie channels, highly edited versions of *Daybreakers* and *Syriana*, which seem like case studies even if I don't want them to be. Each of the narratives is powered respectively by two key pulsed/pulseless flows: blood and oil. In *Daybreakers*, the usual rule of the vampire tale has been inverted. Almost everyone is a vampire, and humans, whose hearts still beat, are a minority, remaining human only to be farmed for their blood or hunted down. The film is a thinly veiled allegory about the totalizing process of capital and consumption, and also a thinly veiled campy romp through various genre tropes. So is the other film. Notwithstanding, the plague that renders all humans into vampires also stops their hearts. And when they discover by chance how to reverse that plague—which had given them eternal

life, but also eternal thirst—their hearts jump-start back into motion. They fall, if you will, back into irreversible time, but that fall comes with an upside, in that when they get their pulses back they can once more measure their own expirations from the inside out. I am probably remembering it all wrong. It would make sense that the vampires in this allegory would be well-heeled, high-design capitalists and scientists. They are trapped in the eternal present of no future, simply because the future is already included in the present time, right at hand. The other film is a series of everyday stories of industrial corruption, state intrigue, and counterterrorism, all driven by oil. Oil is less a flow with a pulse, and more a kind of ubiquitous, aerated, colloidal suspension like blood, obviously. There's a little bit of it everywhere, and pressures in that atmosphere allow it to precipitate with varying effect across the landscapes and narratives it touches. In *Daybreakers*, fantasy beasts lack a pulse. And in *Syriana*, completely banal sites and situations are also driven by a system that lacks an obvious pulse. How to map the "heart" of this? Certainly not with any kind of sphygmomanometer. "A pulsed time is always a territorialized time; regular or not, it's the number of the movement of the step that marks a territory: I cover [parcours] my territory! I can cover it in a thousand ways, not necessarily in a regular rhythm. Each time that I cover or haunt a territory, each time that I claim a territory as mine, I appropriate a pulsed time, or I beat [pulse] a time." (Deleuze)

Kazan, I am told, is full of mosques. I hear again and again that it is "half European and half Asian" (some racist code I do not entirely understand) and an example of how Islam can and should acquiesce to the Russian Federation. It's promoted as a kind of anti-Chechnya. My host asks me about

Kojève out of nowhere, probably pulling random references from writings he found online, so I explain that he was a Russian philosopher, most known for his seminars on Hegel in Paris during the 1930s, largely by their influence on the work of his students and their colleagues, and that these fixed for good and bad how we imagine the pulse and shape of modern history as a logical and dialectic force. "Yeah, so I have to show you this one building then," is his reply to my explanation.

 When we get there, he starts going on about how it was Vertov's dream for his Kino-Eye agents and their lightweight and nomadic film equipment to witness and record everything. They were not only the inventors of data visualization but of machine-vision surveillance as well, I offer. Clearly Kino-Eye was some kind of pulse, wildly distributed across predictive dynamics of emotions and with little personal histories of infrastructure. If we transpose the Kino-Eye back onto our technological landscape, we see montage as capable of collapsing time and space and demonstrating them both back to itself. I was shooting video while we talked, so I have all this down on the audio track. Mastery of the codec—the compression/decompression algorithm—now supplants the skills of the filmmaker and editor, and various crypto-substrates that are directly and indirectly related to the codec become the real field of operation, and thereby the world acquires another ability to communicate with itself; the filmmaker is at best an intermediary. The codec is no longer limited to a chunk of media, a string of images, because its protocols for compression or even encryption migrate across different biological, social, and military domains. The perversely excessive affect of a horror film becomes realistic. Lateral genetic transfers ensure viability, and here even Lamarckian

inheritance resurfaces in certain Eurasian biology faculties, yet it has always been a fine model for cities, architecture, and culture, as buildings always inherit traits directly from their environments through building codes and aesthetic revolutions. That building over there next to the train station is definitely Lamarckian. The informational-genetic pulse is the protocol that governs the channel across which information ecologies flicker, amplify, run amok; they are an architecture in which their innovation is housed. But this idea is where it all goes wrong. The idea that large-scale technological development (particularly information computing technology) properly distributed among the people is the way forward for regimes like this one here is a zombie policy, a walking quasi death but one that is well-funded in economic and symbolic capital. It is even more so when its cynicism is itself the rationale for the investment.

I move between more or less similar café spots inside the hotel district as instructed, eating overly sweet cakes and 7UP, organizing my notes, revising my presentation for whomever it is I will be giving my presentation to. It could be at an auditorium of 500 dignitaries, or at a hotel bar at 11:00 p.m. to the Prime Minister's nephew. I prepare for both. I think about a word processor designed for our thirty-five-foot long tiled display system, one that would allow an author to write and edit in fifty-thousand-word chunks at a time. A twenty-five-foot manuscript. Word processing like this would probably ruin writing in new ways, making words not only into informants but into zoomable pixels; making their animation take on a different concern than semantic nuance. Perhaps a mega-word processor such as this would eradicate the Word as such altogether. Rub it write out again. Once we went back to

the data center in Kazan, the conversation quickly turned to how to push IBM and Cisco and the others out of the way, so as to leverage the credibility of an academic joint venture between my institute and the Kazan IT Park to develop a more comprehensive digital strategy around the Hockey Europa Cup two years hence, which turns out to be the actual focal point for all infrastructural investment happening in the foreseeable future within this region. That turns out to be the point. The other five cities that were supposed to have IT Parks basically spent all the money greasing the local clans and built nothing. Kazan actually built theirs, for whatever reason. The dog man tells everyone about a company called STARSight, all former Mossad, he claims, that does embedded surveillance and data analysis for sensitive public locations such as the Eiffel Tower and the Statue of Liberty, and says how anxious he is to bring them in for a pilot project. "What could we do with them?" he asks. I decide not to give him my first thought on that.

 Later, my host and I stroll through the city looking at the new and old architectural curiosities. He shows me a wonderful but crumbling low-rise office complex from the 1930s that he says is his favorite building in the city. It turns out he and I have more in common than I'd originally thought. "This is that building I wanted to show you," he says finally. I tell him that I remember that when I landed in Moscow at 1:00 a.m. we were delayed getting off the plane just so that a large nurse could go up and down the aisle pointing a square metal gun-like instrument at each of us one by one, which emitted some sort of directed green beam that sensed our ambient temperature. The Dutch woman next to me on the sidewalk, who spoke English, said loudly: "Swine flu." Everybody checked out okay. Over

drinks I tell the dog-nosed man with the bright idea for a joint venture between a Mossad public surveillance start-up and the University of California, so as to shake down some Euro-Hockey money, that the histories of California and Russia have been intertwined throughout the last century, and that now it would be best for everyone if we designed what comes next together.

Moving away from hockey, I diplomatically insist that a program of strategic decentralization is the best. Now they have to put technology in the hands of the public, get out of the way, and support things that are working. Strongman permission as to what goes on every server in this boiling building just isn't going to work. Plan to not plan. This of course may be good in theory, but nobody has been able to decentralize Russian authority ever, so what I am suggesting is basically as insane as his Mossad/UC/Hockey scam. Look at China, I say. They look at me like they assume I am being mistranslated. Look at it? It is my understanding at this point that my host translates my ideas this way: IT has its own momentum that governments cannot control, but can only work with; handheld media will be more important than desktop systems; the Russians are well positioned to leapfrog development if they are smart and willing; and one thing central planning could do is buy a quarter of a million Netbooks and give them away to schoolchildren. The others add parenthetically that mobile gaming and gambling will be crucial to the region's development.

Once my host tells me what was said, later than night, I tell him that's not at all what I meant. But maybe he's more right than me. Maybe the best they can hope for is a fun ride as the global onslaught of phone-based cash economies of vice becomes, by default, Tatarstan's economic strategy?

They seem to know this perfectly well, and I am probably the naive one. What else am I supposed to say? It would be useless to explain how the agonistic relations between Google and jihadi universalism are actually part of the same liquidification of Westphalian territorial jurisdiction, so what the hell. Sure, Eurasia. Aleksandr Dugin gambling apps on your dashcam. It's just stupid enough to work.

 Heading back on the lone return flight, I still don't know what just happened. What did I just do? What would systems without a pulse be? Could they ever be "alive"? Or, better, what is non-pulsed time? Am I supposed to draw a parallel between the negative aspects of non-pulsed systems (given the actual louche, satirical form in *Daybreakers*) writ large as the global system? With its unrestrained superimpositions of entropy, land development, narrative; these are the gems of the genre that have worked for countless years, to take the pulse of the "walking dead" economic form. If we must be optimistic, we could say that, for all the vampire characters who we've loved before, there might still be some reanimation possible if the domains of pulsed time and non-pulsed time could actually merge in a way that involved us directly. Yes? No? A return to the a-metric. Aion plus Chronos equals cognition? Is this coevolution with alien time indeed real, or could it be? Not that we would recognize it, even if it was right in front of us.

On Deprofessionalizing Surgery

Overview

At the Center for the Future of Surgery at the University of California, San Diego School of Medicine, medical students learn to operate surgical robots. The surgeon sits at a control station with her eyes focused into a fixed stereoscopic viewer. In each hand she manipulates extremely nimble rotational controllers to guide four robotic arms through the procedure. At the tip of each arm may be a scalpel, scissors, a Bovie Cauterizer, a fiber-optic camera or light, or any of several other attachments. With her feet, she chooses which arm she wishes to control by hand. A few feet away, the patient lies prone on the surgical table as the robotic tools move in and out of the incision.

Robotic systems provide the surgeon with enhanced visualization and dexterity, and greater precision and comfort. They are an extension of laparoscopic, minimally invasive techniques. In time, more advanced systems may allow the automation of some tasks, the incorporation of outcome-specific artificial intelligence, and the performance of otherwise impossible surgical procedures, such as the precise reconnection of severed nerve fibers. If bandwidth were sufficient and stable, next-generation systems could be part of a remote tele-surgery infrastructure and/or a stable automated surgery economy. During an initial tour of the center's facility, I was able to sit in the surgical seat and to manipulate the controllers myself. Once one experiences how nimble the physical interface actually is, it is not difficult to imagine how the apparatus could be used for these purposes.

In conjunction with the center, we hosted a summer camp for kids aged eleven to fourteen with an interest in science and medicine to undergo basic skills training in the robotic Da Vinci Surgical

System. Some were accomplished video game players, so making the switch to this console was not very difficult. But for others, the learning curve was steeper. We found that after the six weeks of camp, the students who were the most patient were the most proficient, not necessarily those with the most technical dexterity at the outset. Students were scored on both accuracy and speed, and were awarded the same unit credits that the medical school students receive for this training.

Adult surgical students train by practicing surgery on pigs, but only after they have mastered feats of remote-controlled dexterity. These training exercises involve sorting tiny objects and placing them in exact positions and patterns; they are a bit like sewing and a bit like miniaturized stacking games. Abstracted from surgical application, anyone with enough hand-eye coordination and patience could master these exercises, even children.

In the end, we had a small battalion of kids who were now credentialed in the latest techniques for gallbladder removal, hysterectomy, mitral valve repair, cystectomy, and bowel resection; two of them also qualified for cardiac revascularization.

Outcomes

When Herbert Marcuse was a Professor of Philosophy at UC San Diego, he wrote about how automation might alter social relations in a capitalist economy by making it unnecessary for humans to perform certain kinds of skilled and unskilled labor. He wondered how automation could be used to realize a society based on exploring free time instead of acquiescence to the time of capital.

We now recognize the ongoing paradoxes of automation, including that of professional deskilling and the democratization of proficiencies.

That is, as work is de-skilled then tacit knowledge is lost, but at the same time, tasks that would otherwise require highly trained experts are partially automated and can be done by many more people. Automation may lead to a de-division of labor; more people may do more things based on a shallower depth of knowledge.

Some of the worries of the summer camp students' parents were borne out and others were not. The little brother of one student did cut open his own forearm to prove to his friends in first grade that his older brother in eighth grade could fix it. Other students declared after camp that they wanted to go to medical school, to open hospitals and clinics in the developing world, and to make modern surgical services available to everyone.

This camp is one of many innovative initiatives at the UC San Diego School of Medicine. The school is known to have among the most rigorous computer science requirements for its medical students. Beyond basic data structures, they learn information theory, advanced data visualization techniques, advanced statistics, and various application programming stacks. The rationale is that a doctor must not only be able to interpret noisy data sets, he must also be knowledgeable about the workings of his software-based tools so that he can modify them as needed (or better yet, so he can program new ones).

For legal reasons the summer camp students were not able to practice on pigs in the same way that the adult surgical students do. They do not have sufficient training in anatomy or physiology, let alone internal medicine, and so the pigs (even dead) are legally protected from being mutilated by the untrained. In many high school biology classes the internal organs of fetal pigs are pulverized by incompetent ninth graders, and the participation waiver

that those students' parents sign does not cover the eventualities of robotically assisted surgery.

Instead, the summer camp students were trained to dissect a pig's skin into standard four-inch by four-inch squares, removed from the animal's body in a grid pattern. These thick, regular cadaverous tissue samples were then made available to other laboratories on campus for early-phase testing of new technologies before they are tested on human skin. By the close of camp, the students had produced around one hundred tissue sample squares that met all specifications and were put into circulation. Based on an earlier collaboration, we proffered several squares to partners at the Department of Nanoengineering where tests on ink-based chemical sensors tattooed onto mammal skin are being prototyped and perfected. These biosensors can be designed to sense chemical changes in the host body or in the external environment, but it must first be determined that the nanoparticles do not poison the tissue.

The final stage of this project was a performance and installation at the La Jolla Museum of Contemporary Art, in the main gallery space of the Venturi Scott Brown building overlooking the Pacific Ocean. Three of the Da Vinci Surgical Systems, costing nearly two million dollars each, were moved from campus downhill to the museum, at the considerable expense of a special donor. On opening night, the three surgical stations were arranged in a dramatic triptych and manned by a trio of the most accomplished summer camp students. Three spotlight columns beamed down, each illuminating one station, where a student performed triumphs of remote-controlled adroitness and tissue subsectioning before a silent crowd of several hundred.

Next Steps

Enabling a robust long-distance telesurgery infrastructure is complex but not insurmountable. Today, though it requires two systems, one in each location, it can be done. In 2001, Dr. Jacques Marescaux performed a successful procedure in New York, which he piloted from Strasbourg. Such a configuration demands a fiber-optic connection between the systems with absolute minimal latency and maximal security of packet exchange.

More recent projects have had mixed results, as they attempt to realize similar outcomes under less than ideal network conditions. One project, based at the University of Toronto, sought to demonstrate surgery over the Open Internet, using only the bare minimum of technical support at the surgical site. The goal was to determine if remote surgery could be performed in parts of the world where state-of-the-art clinics and bandwidth infrastructure are not available. They used no dedicated bandwidth, other than basic SSL (Secure Socket Layer) connections, in order to show what is possible over nonspecialized, public information networks. The researchers claim that the project's failure was due, in large part, to relay problems caused by "net neutrality" rules that do not differentiate and prioritize certain forms of data traffic over others. This conclusion was disputed and criticized, but the necessity for very stable, high-resolution links between surgeon and patient is not controversial.

The successful development of a telesurgery system for the developing world may require bringing systems much closer to the patients and designing purpose-dedicated networks for linking the surgeon and surgical theater. It will also require a dramatic drop in price, availability, and reprogrammability of these tools. For example, one of the

side projects of the summer camp was launching a medical hardware Torrent Search Engine. One student perfected 3-D printable CAD files for a rectal stapler commonly used in hemorrhoidal surgery, which he then used as the inaugural seed torrent for the search engine. Within days there were dozens of similar files of varying degrees of quality.

We are now working with the Distributed Health Lab (DHL) based at the California Institute of Telecommunications and Information Technology, also at UC San Diego. The lab has already deployed an iPad-based "Clinic in a Box" that includes a clinician's basic diagnostic tools, such as a rugged microscopic sample viewer. The kit compresses several core tools into a highly portable and modifiable platform, and we are collaboratively designing an experimental protocol for adding remote, robotically mediated surgery. DHL's main clinical base is in Mozambique, where abortion was decriminalized only very recently. Access remains very difficult, and dangerous amateur surgery is commonplace. The plan is that by using a head-mounted display prototype (essentially a more advanced Oculus Rift), a dedicated gigabit mesh network linking a circuit of bare-bones surgical facilities, and a miniaturized robotic surgical system originally designed for small manufacturing assembly, the DHL platform may be able to offer services in a much safer context to more women.

Another barrier to experimentation with robotic surgery is the careful regulatory environments of North America, Europe, and Asia. Places where surgery is most needed but least available are sometimes also where such restrictions are less prohibitive, and so it may be that the most significant advances toward a robust long-distance telesurgery infrastructure will originate from these

areas and then only later spread to more developed economies. Automation will mitigate some risks, and perhaps amplify others, but in ways that do not track current FDA, AMA, and FTC guidelines and orthodoxies. Fortunately, best practices learned from field trials at the DHL clinic in Mozambique are finding their way back into the Center for the Future of Surgery curriculum.

Benjamin H. Bratton
Dispute Plan to Prevent Future Luxury Constitution

ISBN 978-3-95679-195-6

© 2015 Benjamin H. Bratton, e-flux, Inc., Sternberg Press. All rights reserved, including the right of reproduction in whole or in part in any form.

Publisher
Sternberg Press

Series editors
Julieta Aranda
Brian Kuan Wood
Anton Vidokle

Managing editors
Kaye Cain-Nielsen
Mariana Silva

Copyediting and proofreading
Laura Preston
Elvia Wilk

Design
Jeff Ramsey

For further information, contact
journal@e-flux.com
www.e-flux.com/journal

Sternberg Press
Caroline Schneider
Karl-Marx-Allee 78
D-10243 Berlin
www.sternberg-press.com